CW00551694

'*Homegrown* is electric. Raw, honest, and compelling, no other play has so richly explored current discussions of radicalisation, Islamophobia, and youth disaffection.'

Arun Kundnani, author of *The End of Tolerance: Racism in 21st Century Britain* and *The Muslims are Coming!: Islamophobia, Extremism, and the Domestic War on Terror*

'In the words of sociologist Les Back, "Our culture is one that speaks rather than listens". Communication via social media has become a form of breathing, each and every citizen with their own mouthpiece that enables them to babble their innermost thoughts and spar with infinite strangers. Yet these interactions take place through ever-narrowing channels; fear of disagreement, of falling-out, of saying the wrong thing, of being overheard, can stifle the promise of getting to know anyone who is not already like us. The ability to read about everything and anything means we are in danger of learning nothing in any depth or with serious engagement.

And in this maelstrom, while everyone chatters, it has never been easier for the state to eavesdrop on the most private of conversations. While this drastic encroachment upon our privacy demeans us all by curbing our ability to speak freely, it is too easy to stand by while some, a minority, are routinely targeted for extreme surveillance. The effect is to intimidate, to close down any debates about what exactly is the danger we are told we are facing. As a result, it has become so much more important, not just to talk to each other outside these narrow channels, but to stop and listen as well.

To read *Homegrown* is to encounter a world we might never normally enter. It is its own public sphere – for it cannot be confined to just one secondary school in London – fizzing with wit, intelligence and wisdom, interlaced with ignorance, innocence and the voices of inexperience. There are levels of prejudice and fear to be expected among teenage protagonists living in the 21st century, just as there are strong currents of kindness, love and solidarity. To follow the characters as they negotiate each others' anxieties, dread, suspicion, friendships and alliances, can be uncomfortable, even alarming. But it can also be heart-warming and reassuring.

To read *Homegrown*, and to imagine its live performance, is to become open to points of view completely hidden and unheard in today's clamorous world.'

Vron Ware, author of *Who Cares About Britishness?: A Global View of the National Identity Debate* and *Military Migrants: Fighting for Your Country*

HOMEGROWN

Omar El-Khairy
created with Nadia Latif

HOMEGROWN

fly πrates

London

First published in 2017 by fly πrates

Copyright © Omar El-Khairy and Nadia Latif, 2017

Omar El-Khairy is hereby identified as author of this play
in accordance with section 77 of the Copyright, Designs and
Patents Act 1988. The author has asserted his moral rights.

PB ISBN: 978-0-9957577-0-7
E ISBN: 978-0-9957577-1-4

Images copyright © Lorna Ritchie, 2017

Cover design by Daisy Rockwell

Homegrown

a new play by Omar El-Khairy
created with Nadia Latif
in part devised with the cast

CAST

Poppy Almond
Fran Amewudah-Rivers
Billy Ashcroft
Anshula Bain
Donna Banya
Saul Barrett
Karim Benotmane
Holly Bodimeade
Noah Burdett
Hannah Caplan
Eliza Cass
Anna Chedham-Cooper
Angelina Chudi
Rachel Clarke
Cayvan Coates
Grace Cooper Milton
Jack Cooper Stimpson
James Coutsavlis
Lydia Crosher
Ailema De Sousa
Vanessa Dos Santos
Rosie Dwyer
Daisy Edgar-Jones
Priya Edwards
Hannah Eggleton
Charlotte Elvin

Daisy Faircluff
Meg Forgan
Ryan Francis
Megan Freeborn
Matthew Galloway
Lisa Ghosn
Elliot Gibbons
Christine Gomes
Brad Goss
Katie Greenall
Shakeel Haakim
David Hall
Nancy Hall
Lizzy Hammerton
Tsion Habte
Alex Heath
Caitlin Heaton
Molly Howell
Gemima Hull
Humaira Iqbal
Shiv Jalota
Michelle Jamieson
Sam Johnson
Viveik Kalra
Sam Larner
Joshua Levy

Qasim Mahmood
Mohammed Mansaray
Julia Masli
Oliver Maynard
Henry Mccook-Rouquairol
Sammy Meikle
Lucy Miller
Reece Miller
Miles Molan
Lauren Moore
Katya Morrison
Jessica Murdoch
Corey Mylchreest
Marie Myrie
Marilyn Nadebe
Charlie O'Conor
Sean O'Driscoll
Kofi Odoom
Amara Okereke
Matt Parkinson
Chance Perdomo
Gabriella Pond
Dan Rainford
Matthew Rawcliffe
Flora Raynham

Sam Rees Baylis
Patrick Riley
Eddie-Joe Robinson
Molly Rolfe
Raagni Sharma
Madeleine Shenai
Mani Sidhu
Barbara Smith
Catherine Snow
Rhys Stephenson
Sophie Stockwell
Jodie Sully
Claudia Summers
Amy Squires
Will Stuart
Kai Thorne
Callum Tilling
Nathaniel Wade
Minnie Walker
Aled Williams
Jem Wilson
Megan Wilson
Dougie Wood
Evie Woods
Yemurai Zvaraya

CREATIVE TEAM

Writer **Omar El-Khairy**
Director **Nadia Latif**
Designer **Lorna Ritchie**
Movement **Mina Aidoo**
Associate Directors **Paris Erotokritou** and **Keziah Serreau**

Characters

All of secondary school age (14 to 18)

AISHA, *POC*

LAILA, *POC*

FAROUK, *POC*

Tour Guides

AMARA, *black*

COREY, *white*

MOHAMMED, *dark-skinned, middle class, Christian*

DAISY, *light-skinned, working class*

LISA, *Arab*

EDDIE-JOE, *white*

SHIV, *Asian*

NANCY, *white*

NATHANIEL, *black*

CHARLIE, *white*

All other parts are to be played by members of the company. Unless specified, gender and ethnicity are open to interpretation.

Setting

A secondary school. East London. 2015

A dash (–) denotes an interruption or change in thought/intention in dialogue.

A forward slash (/) denotes an interruption by another character so that lines might overlap.

An asterisk () denotes whole lines spoken simultaneously.*

An ellipsis […] denotes a silent but distinct response.

Acknowledgments

These are not your typical acknowledgments. We would usually be thanking all those who helped make this play happen. However, we are living in exceptional times, so our love goes out to all those who took a stand with us. They know who they are, and we are humbled by their friendship, support and solidarity. Many wish to remain anonymous. But we would like to thank Shami Chakrabati, Mairi Clare Rogers, James Welch, the incredible team at Liberty, David Heinemann and the Index on Censorship family, English PEN, Madani Younis, Elyse Dodgson, David Lan, Josie Rourke, Rupert Goold, Jessica Cooper and Vron Ware for their unwavering esprit de corps.

A number of the original cast gave up their time to workshop unfinished scenes, and we would like to thank each of them. We could not have finished it without them. Taio Lawson, you have been an immense friend, a well of comfort, and your insight during these workshops was invaluable. And to Roland Smith, Jessica Brewster and the Theatre Delicatessen team for their immense generosity in giving us both refuge and space to finish making the play. We cannot thank you enough.

We owe a huge debt of gratitude to many people who have helped bring this publication to fruition. Kim Slim, our editor – and his trusty sidekick, Mr. Sickman – you are rogue legends. Bless you, sirs. Ana Naomi de Sousa, your patience, rigour and exacting eye were a saviour, thank you.

Finally, we would like thank readers in advance, for their open minds and imaginations.

A History of Homegrown

At the beginning of 2015, the National Youth Theatre (NYT) approached us with an idea for a show – a large scale, site specific, immersive play looking at the radicalisation of young British Muslims. *Homegrown* was intended to be an exploration of radicalisation, the stories behind the headlines, and the perceptions and realities of Islam and Muslim communities in Britain today. Trouble was first encountered when, the day after announcing the show to the press, our original venue of Raine's Academy in Bethnal Green withdrew, after pressure from Tower Hamlets council. We were asked to keep silent so that a new venue could be secured. The official line would be "logistical issues". The show then had to be signed off by Camden Council in order to secure us our eventual venue, UCL Academy in Swiss Cottage. We went into rehearsals with 70% of the show scripted and signed off by the NYT, and the remaining 30% to be devised with the cast during rehearsals. In a production meeting in the first week, we were told that a meeting between the NYT and the police had taken place. We do not know who instigated it. However, the police wanted to read the script, attend the first three shows, plant plain clothes policemen in the audience and sweep daily with the bomb squad. When we protested these measures, asking why the police felt the need to get involved, we were quickly told that the police had no power of ultimatum; and the issue was never raised again.

Rehearsals were brilliant, on schedule and exceeded all of our expectations. We were filled with nothing but admiration and deep respect for our amazing cast, who were taking the material and running with it. Exactly halfway through the process, the NYT came in to see rehearsals for the first time. They left full of praise and with a number of helpful suggestions. That night, we received an email from the NYT telling us that *Homegrown* was cancelled. There was no warning, no consultation and no explanation – indeed, they even attempted to prevent us from

entering the building the next morning when we came to collect our things. All our attempts at meeting with the NYT have been delayed and then cancelled.

Since then, there have been a number of public statements and emails made public through Freedom of Information requests. These prove many contested claims, including that the NYT had met with the police (which both parties had previously publicly denied), that both Tower Hamlets and Camden councils had been involved, that the decision to cancel the show had taken place before the NYT had seen any rehearsals and that the Arts Council was unhappy with how the show had been pulled. In an email, made public, from Paul Roseby (Artistic Director of the NYT) to the Arts Council and the NYT board, he wrote that "[Omar and Nadia] have failed to justify their extremist agenda".

Determined that nothing would keep us from finishing *Homegrown*, we returned to finish rehearsing the show in secret in December 2015 with the original cast, in a space kindly donated to us by Theatre Delicatessen. Our original publishers had committed to publishing the text, even without a production, and we knew that, if for no other reason than the sheer scale of the show, that publishing it might be the only way it would ever see the light of day in its entirety. However, after extensive discussions, our publishers then decided that they would not be publishing the play – as they feared being "another Charlie Hebdo". Undeterred, we sought out other publishers, but came up against similar problems. We finally realised that self-publication would be the only way that *Homegrown* would get into the world.

Author's Note

There's no point in saying these numbers to us anymore because we've seen them, yeah. So, now everyone's head's on putting this thing on the map in a way that all the kids of today never have to go through what we went through.

– Skepta

On picking up the Mercury Prize, with his parents and crew in tow, Skepta spoke candidly about the persistent strain of trying to figure out the music industry. It was not until he decided to do it for himself – and the crew, the family – without the backing of a record label, that it all began to make sense. For many of us, this was an emotional moment. We have witnessed gifted writers and artists of colour either dismissed or exploited – many driven to depression – by the various culture industries. Despite a degree of well-intentioned energy being expended on addressing institutional racism and sexism, as well as concurrent efforts to try and correct this with conversations and initiatives around diversity and representation, others are more invested in getting on with living, loving and creating on their own terms. If mainstream industries and institutions neither represent nor reflect us, then we will do it for ourselves.

Thinking about the self-publication of *Homegrown* in this way reminds me of the Martinican philosopher Édouard Glissant, who was deeply involved in the anticolonial movements of the fifties and sixties. One of Glissant's main projects was an exploration of 'opacity'. He defined it as a right to not have to be understood on other's terms, a right to be misunderstood. He sought to defend the obscurity and inscrutability of Caribbean blacks and other marginalised peoples. For, external pressures always insisted on everything being illuminated, simplified and explained. However, Glissant's refusal suggests that there is another way.

Whether it is Skepta skanking outside the Barbican in his all-white garms or Donae'o, JME and Dizzee Rascal cotching in straight black trackies, they all have the right to obfuscation – to the protection of the shade. The same holds true for those at the heart of this play, the two groups most caught up in this violent bind of legibility and opacity – Muslims and young people. In this spirit, I hope *Homegrown* serves as a work that torments visibility, and uses our assumed clarity on the topics du jour in a productively ambiguous manner.

Director's Note

This original full version of *Homegrown* was meant to use an entire school building and a cast of 115 teenagers. However, we always intended for the play to be flexible enough to be done with smaller casts – in one room, if necessary. The easiest way to do that would be to choose one tour guide strand, the one that best fits the available cast. Scenes should stay in their strands, in the prescribed order, so do not chop and change them. Each tour guide strand must end with the verbatim play, but actors can double up and play as many characters as necessary in this section (except for the two interviewers). We have tried to be as specific as possible regarding race and gender, so obey the specifics where given, but embrace the flexibility where there is no indication. Our production was intended to be promenade, with the tour guides physically shepherding the audience groups from scene to scene in different rooms. However, you could equally have your audience in a fixed, traditional relationship to them as the scene changes behind them. The tour guides must not appear in scenes until indicated.

Our biggest influence in making this show was horror – everything from body horror and monster movies to Victorian ghost stories and B-movie schlock. It should permeate the show, maybe starting as something slightly uncanny, unreal or out of place, building to full on terror – with children running, screaming down corridors without explanation, lights flickering and a genuine fear of what lies behind each door. In performances, this might manifest in the first couple of scenes seeming entirely natural, but they become increasingly strange – not fitting with the bodies performing them. If at all possible, there should be a visual sense of doubling back on oneself and things being deliberately altered by invisible forces.

It is important to recognise that each strand takes both the tour guides and the audience through a range of opinions and

stances. Do not normalise these views, or digest them all. Some are purposely aggressive or left-field. The audience, of course, do not have to agree with everything they hear, but equally neither do the tour guides. Investigate the space between what is deemed acceptable and what is intelligible. Make bold decisions. Be brave.

Devising Note

Part of our process was devising additional material that would be dotted throughout the show and around our venue. As we wanted the piece to respond both to contemporary issues and the concerns the cast were vocalising in workshops, we had them trawl newspapers daily and come in with articles, images or videos that they felt we could use.

Though the scenes as published must remain intact and in the published order, feel free to devise material to get you from scene to scene. Rather than textual, this should be visual or movement based. Our movement director looked at an enormous range of movement styles; everything from Sufi prayers to Fosse, via daggering and military drills. Many of these sequences were just colour – reminders to the audience that what they are seeing is at times very real, and at other times, purposefully weird and uncomfortable. Some material featured within scenes. Imagine a scene that might appear to be a straightforward monologue, but think what happens to it when the room is full of bodies forced into stress positions. All this material is meant to enhance the text by sitting alongside it. It should not feel like musical numbers.

Another option might be to get your cast to devise visuals that could be incorporated into the set. Some drawings of visual materials – in the form of poster campaigns – have been included in the text (but must not be reproduced without permission). Our cast devised pretend campaigns that featured throughout our set. These were based on the sort of action campaigns that one might see in schools (for example, eating your fruit and veg, helping your fellow student or extracurricular reading), but with their own spin on them (#friendorfoe or #goodmuslimbadmuslim).

My father said: Your brother shaved before his beard started to grow

Your brother saw the terrorist's face in the mirror

and wanted a flat iron for Christmas

My brother said: Some day I want to die in a country

where people can pronounce my name

– Athena Farrokhzad *White Blight*

For our Homegrown young'uns

PRE-SHOW

The makeshift box office is set up in the school foyer. All box office staff are in character and costume – as teachers.

All tickets must be collected from the box office. On collection of their ticket, each audience member is handed a coloured wristband. These are given out systematically (e.g. red, blue, yellow, green, orange) to ensure that there are even numbered groups in each colour. They are also given regardless of whether two people have come together. It is important that the box office staff do not explain to the audience why they have been given wristbands – it is simply how it works.

The audience wait outside the theatre space – in the area through the foyer.

As an expectant audience continue waiting, children emerge for the very first time. We see a couple of kids, only a handful, popping their heads around curtains and corners – giggling, messing around with one another, teasing the audience and/or looking out for family and/or friends. At this point, they are all playing themselves. Each night, two or three cast members who know they have family and/or friends in the audience that evening breach that divide to greet them.

It is time for the show to begin.

The audience need to grow a little impatient. Any latecomers, held at the box office until now, trickle into the holding space. The audience are beginning to look at their watches by this point. Three school children (AISHA, LAILA and FAROUK) burst into the holding space – all in a blaze of frustration and anger, all laced with a heavy dose of expletives. They are racially marked – the first students of colour the audience encounter. They are wearing a mix of costumes, uniforms and home clothes – and carrying bags of varying sizes. After a few choice words – "This is bullshit", "I'm done, man", "Fuck this show", "Technical difficulty, yeah?" etc. – this group leaves the school through the main entrance – in full view of the audience. A momentary sense of chaos – anything feels possible right now.

The show is now five minutes late.

An adult voice comes over the tannoy, too loud to be ignored. It tells the audience that the show has been delayed. He/She gives no specific reason and asks everyone to bear with him/her. The tour guides appear – a pair for each audience group – all in school uniform and with their prefect badges in clear view. As they appear, the voice on the tannoy comes back and tells us that there has been a technical fault – and the show is now running half an hour late. But fear not, this will be filled by taking the audience on a tour of the school and its facilities. The audience should get into groups based on the colour of their wristband. Each tour guide pairing is now in charge of one of these groups.

UNITED
IN
EFFORT

TOUR 1: AMARA & COREY

SCENE ONE

The audience overhear this conversation.

(Pause.)

AMARA […]

(Pause.)

AMARA […]

(Pause.)

AMARA Aren't you –

COREY […]

AMARA You're just going to – like nothing happened – like you haven't –

COREY […]

AMARA Everyone's seen them.

COREY Not now.

AMARA The whole fucking school.

COREY Just calm down.

AMARA Calm down?

COREY Yeah, you're starting to embarrass yourself.

AMARA Where do you get the nerve?

COREY […]

AMARA *(Beat.)* Huh? Tell me.

COREY *(Beat.)* You're fit, right?

AMARA What?

COREY You're not ugly, yes?

AMARA [...]

COREY The photos – they're flattering.

AMARA You're unbelievable, you /

COREY / Imagine it was – Angie. *(Shuddering.) (Beat.)* Gross. Or Habiba. Fuck. Her dad would behead her.

AMARA *(Beat.)* You're a prick.

COREY Right.

AMARA You fucking are.

COREY Tell me something I don't know.

AMARA Why did you do it?

COREY [...]

AMARA Huh?

COREY [...]

AMARA *(Beat.)* It's been a while.

COREY [...]

AMARA You still want it.

COREY Come on now.

AMARA Is that it?

COREY Get over yourself.

AMARA You just can't accept not getting what you want for once, can you?

COREY [...]

AMARA So, you do what you do best – and act like a spoilt little brat. *(Beat.)* It's getting pathetic.

COREY You think I did –

(Beat.) The perpetual victims – always.

AMARA What did you say?

COREY I said, it's always someone else's fault with you. Historical legacy this, historical legacy that – you just can't take responsibility for anything, can you?

AMARA I'm not even going to /

COREY / Look at Aisha.

AMARA What about Aisha?

COREY Technical fault?

(Beat.) You reckon?

AMARA What you trying to say?

COREY I'm saying your BFF has got herself caught up in some shit.

AMARA You're just being a spiteful /

COREY / You don't? *(Beat.)* No? *(Beat.)* Aisha, Farouk and Laila.

(Beat.) Nothing? You can't – you don't want to entertain –

AMARA [...]

COREY *(Beat.)* No. Fair enough.

(Beat.) You're thinking it though.

AMARA [...]

COREY Liberal blindness – it'll be our death knell.

SCENE TWO

The audience are in a classroom full of kids who look like they could be rehearsing a scene from the delayed play. It is well put together and earnestly performed. They are conscious of each other and of the piece as a whole. They

*are animated. An actor can play more than one part, but the characters
must be distinct through voice and physicality.*

A 08:37, King's Cross, getting on the circle line.

B I'm running late, so I rush to the tube at Liverpool Street
Station. I run down the steps, and I can hear the beeping of
the doors as they're about to close – but I get through them
like a boss. I look at my phone – I've got three missed calls.
Fuck, I'm late.

C I think I'm not receiving some of my post at the moment, so
forgive me if my reply is slow. I had another brick through my
window last night. It's the third one this month. This one has
a note attached to it. The same Paki nonsense. At least no shit
this time.

A I clock the watchful eyes on me – tick box terrorist. Maybe I
should shave? 08:39, Farringdon. Not late, but cutting it.

D Therapy isn't working.

E I'm okay.

D Telling me my fear's unfounded.

F Buys a 9-volt battery.

A 08:40, I eye an empty chair, then see another woman eyeing up
the same chair. I let her sit.

G Bit of a mess, really.

H My face is wet. I don't know why.

I I'm sitting, eating my cereal and listening to that Rihanna song
Umbrella on the radio – until, I'm interrupted by a special
announcement. Before I can stop myself saying "fucking
Muslims".

A Moorgate, 08:42. I see a fellow tick box terrorist get on – our
gaze lingers. The watchful eyes notice us both.

D Always hated Circle line trains.

J Dear British police. A member of your team stop and searched me again last night on the 754 service to Edgware. I appreciate that I must have been a cause for concern, what with my brown skin, beard and large rucksack. I only ask that you be more discrete next time – as not to publicly humiliate me.

A Liverpool Street, 08:45. There's space, we have room. The train's packed, but people give us room – our tick box terrorist radius. It's got some advantages.

K This is going to fucking hurt.

A 08:48.

L Don't weep for me, my love. Allah's love for me is the greatest – and He has chosen me to join Him in paradise. Don't pray – for I'm safe. Forgive those responsible, they're misguided, and must be lead towards the true path of Allah.

M Is this dead?

N My mouth tastes of dirt and blood –

E My Adidas trainers are on the ceiling.

B The first thing I do is check my phone – see what time it is. I don't realise that the light from my phone is the only source of light in the carriage.

O I can't see anything. I can't – where's my hijab gone? I had it just a minute ago. I chose the red one with the lace because I was seeing Mike today. He's not going to know. He'll just be waiting. No one will tell him.

I I turn back to my boyfriend. Tears are streaming down his face because his brother's office is in Tavistock Square. I can't bear to see him sad. "Fucking Muslims". I look him dead in the eye – and say it again. "Fucking Muslims". He takes his phone out and tries to call his brother, looks me dead in the eye, and under his breath, keeps repeating it.

E Come on. Get up – let's go.

P Someone must have pulled me through a door or something. I think people were trying to break the glass. Suddenly, there were hundreds of people crushing against the tunnel walls; chocking and bleeding and crying.

N I'm being rolled onto my side.

Q My mum. God, the last thing I said to her – I can't stop hearing the anger in my voice when she asked me if I wanted to go with her to mosque on Friday. She didn't deserve that.

N When's the bus coming? Where's the bus?

SCENE THREE

COREY (*Laughing.*) [...]

AMARA [...]

COREY I mean – fuck's sake.

AMARA Stop it.

COREY (*Still chuckling away.*) [...]

AMARA Cut it out, I said.

COREY Why?

AMARA You've made your point, alright.

COREY You can laugh at it, you know. It's not illegal – yet.

AMARA Why you got to be like that?

It's tiring, you know.

(*Beat.*) Ms. Jenkins is a good teacher – cares about us lot.

COREY You lot.

AMARA Fuck off, Corey.

COREY Cares about the whole fucking world, she does.

AMARA [...]

COREY *(Beat.)* Single mum, right?

AMARA Yeah, and?

COREY She goes out of her way to show people who'd have her
stoned to death –

(Beat.) Why?

AMARA [...]

COREY Huh?

AMARA I don't know.

COREY Go on – tell me. I know you know.

AMARA [...]

COREY Tell me why you think someone – anyone – would go so far
as to apologise for homicidal maniacs who lust over their death.

AMARA You know what, Corey. Why don't you tell me – indulge
me, indulge us all.

COREY Yeah – I will. *(Beat.)* Guilt.

AMARA Of course.

COREY Liberal fucking guilt – everyone's riddled with it.

(Beat.) You remember how she dealt with Farouk?

AMARA Nope.

COREY His 9/11 conspiracy theory piece – Israelis celebrating on
the roof opposite the twin towers.

AMARA I'm sure it was a wonderful piece of creative writing.

COREY You don't get it, do you?

AMARA What, Corey? What don't I get? How different Farouk
is to the rest of us? *(Beat.)* How that renders him incapable of
imagination – of wit or irony?

COREY He is a bit slow.

AMARA You just don't respect anyone, do you?

COREY Oh, come on.

I'm just /

AMARA / No. You don't respect Farouk, you don't respect his faith, you don't – you sure as hell don't respect me.

COREY That's such a cop out.

AMARA Yeah, is it? You don't see any connection?

COREY No – I don't. I mean, they're completely unrelated. You're clutching at straws – clutching, trying to tarnish me with – something.

AMARA Nothing's sacred to you, is it? You love to mock everything – faith, intimacy /

COREY / Stop. I never did you wrong.

AMARA […]

COREY I didn't.

AMARA You can't – no – you don't want to – yeah, you just don't want to recognise me.

COREY You let me – you asked me to take those photos.

AMARA It doesn't make it right – what you did.

COREY […]

AMARA *(Beat.)* Aisha said she saw you.

COREY Saw me what?

AMARA Me with Harrison – at Ashley's party.

COREY *(Beat.)* Aisha's full of shit.

SCENE FOUR

This works in counterpoint to Scene Two – the actors' actions do not always go with the text. On the surface, it may seem like they are just having a casual conversation. Each line must be performed by a different actor to the last – the more random the better. When other people are speaking, some of the actors can engage in normal teenage behavior – the kind that occurs when a teacher is not present. There might be a photograph of Mohammed Emwazi (Jihadi John) projected on the white board.

I don't believe he's a Muslim.

I wish he'd been stopped before he turned.

Whatever the reason he's killing, he has killed. No matter the reason, you can't condone that.

I'm scared he's not dead.

It's the same story over and over again, innit. First it's Jihadi John, next it's Kill 'Em All Kareem. It's madness.

I think this prick is just looking for attention to be honest.

It's just not, you know, British values, cutting people's heads off.

It's against everything the Beatles stood for.

I think he's a dickhead.

I don't want to understand him. Why should I have to?

I'm hungry. Why are we even talking about him?

I'm sure he's on the hunt for a sense of purpose. Shame he thought he found it in Syria.

I question the bombing's legality.

I'm scared he's dead.

It's so sad really, when you think about it. There's obviously something wrong with him.

I don't blame him for wanting to separate himself from the West. I'd want to distance myself from the Kardashians, too.

I think he needs a hug.

It's all so mechanical.

We forgot it's a human, right? Like drones and shit, but the tragedy is human and real.

I think Jihadi John is a crap nickname to be honest.

He represents a wholly new fear, an unfounded fear. Such a shame.

I think he looked like a ninja. That's pretty cool.

I think I'd feel alienated if every other front page was calling me evil.

I hate that I'm being asked to sympathise with a fucking terrorist.

I know they treated him like a terrorist before he even was one.

Kidnapping people and cutting their heads off. Coward, what an absolute fucking coward.

He clearly had enough. You push a man too far, and eventually he'll snap.

It's one less monster who wants you and your children dead.

I just wish we could find a way we could help people like that.

I heard that he's dead now, so who cares. He got what was coming to him.

I know kids like him.

Ill not evil.

I don't hate the brainwashed. I hate those who brainwash.

We got him. We finally fucking got him.

I think he's a monster. The only thing he's missing is scales and a tail.

I personally believe that we need to look at this from his perspective. What would lead a man to do this?

I hope he's not dead.

I hate that we don't know how to properly help these people.

I don't know why people view him as a human being – he is a threat to human beings, and if the Americans didn't really kill him, I hope we do.

I can't blame him for becoming what they wanted him to become.

I always said we should stop these people from getting into our country. Now look, they're fucking turning our own.

I just hope he suffered – like, a lot.

I know if someone punched me in the face, I would punch them back. Isn't that just what Jihadi John has done?

I'm sick of us pussy-footing around these people, it's time we started ending them. I hope it's cold in hell.

I live in the country that was the knife in his back. How can I blame him for surrendering?

I think we should have cut his head off.

I wonder if he was able to see parts of his body being torn apart – if it was just for a second. I'd find that satisfying.

I wish I understood.

We all hold responsibility for the radicalisation of Mohammed Emwazi.

I think if I got stopped and searched the whole time, I'd probably turn around one day and be like, "fuck it, if you want me to be a terrorist, I will".

I think what we need is empathy.

In many ways, we're just as guilty for Alan Henning.

Jihadi John wasn't a born terrorist. He tried to live a normal life – and Britain wouldn't let him.

I get you.

We failed him.

SCENE FIVE

(Pause.)

AMARA [...]

COREY [...]

AMARA Aren't you going to –

 (Beat.) It's not good if we /

COREY / Yeah.

AMARA [...]

COREY [...]

AMARA We should talk about it?

COREY [...]

AMARA *(Beat.)* I don't want – Harrison and I are /

COREY / I'm getting tired of this – all of it. It's tiresome – this whole fucking day.

AMARA [...]

COREY *(Beat.)* I don't see why I have to –

AMARA I get it, I do.

COREY No, I don't think you do.

AMARA O-kay.

COREY There's this constant – this relentless drive today – to show how limp – how redundant white boys like me have become. Even in the smallest of gestures – you see it still.

(Beat.) It's like one gigantic in-joke.

AMARA *(Smiling.)* It is, yeah.

COREY Yeah, you laugh now.

AMARA Oh, come on. You're wallowing – you never /

COREY / No, I'm not. It's clearer than that. It's despair. Despair for what's come of our culture – of its rigour.

(Pointing to the room.) That – in there. It's symptomatic of our loss of any kind of sustained critical thought. We can't even speak our minds anymore – in our own – not at least without being hounded by –

(To Audience.) (Beat.) If you haven't guessed by now, folks – there's no technical fault. Nothing's wrong. Well, except for the fact that three students – three Muslim students have ditched the show to /

AMARA / It resonated with me.

COREY [...]

(Beat.) And why doesn't that surprise me?

AMARA Jihadi John.

I mean –

COREY [...]

AMARA Who even – who's that?

COREY A mass fucking murder.

A savage, barbarous psychopath, maybe.

AMARA Nuh, that's what you see – want to see, in that image. It ain't the guy behind the mask.

It's just –

COREY Just what?

AMARA Reducing him to – to this – I don't see how that helps anyone.

COREY It helps us maintain everything we know to be right – in our core.

AMARA By turning him into this – almost computer game-like monster.

COREY Well, he doesn't share our humanity, rejects it with every fibre of his being, so – I don't understand why you're so adamant on finding some kind of justification to his act.

AMARA I'm not. Far from it.

(Beat.) But when I looked at that photo of him in there, I wondered what all those people thought of me when they saw those photos of me.

COREY [...]

Fuck.

AMARA What was I worth to them – right then?

In that moment, did we share that common humanity? Or was I just some –

(Beat.) Yeah.

SCENE SIX

This scene can be performed with as many POC actors as you have available – but they must all be POC. The scene should look like a very orderly classroom, where they have all been instructed to watch an educational video. We used the 'Porky Pig: Ali Baba Bound' cartoon, but you might equally have them watching another racist film, cartoon, minstrel show etc. The lines may be divided as you like.

Can I touch it?

The position's filled, sorry / Oh, you're not hiring.

Makes generic African clicking consonant sounds.

Do you use shampoo?

Is it bigger?

He's too street.

How do you wash your hair?

Where you from?

You speak well.

"Hey girl!" *(Snaps fingers.)*

Do you know who you look like?

I don't date them / I just don't fancy them.

Teach me how to twerk.

Don't jazz it up.

Can you turn on the subtitles?

Are you scared of dogs?

You've probably heard this before, but –

Can you swim?

I saw that documentary.

Is it real?

Do you see him often?

Is that halal?

Can I call you –

Kisses teeth.

Do you mind me having this in front of you?

No, like originally?

How high can you jump?

I didn't notice.

Is it horse?

Say it slower.

Are your parents okay with that?

Should I take my shoes off?

I bet they love you.

Don't all lives matter?

Which one of your parents is –

What do you speak at home?

I'd love to visit.

Do they do your shade?

Are you allowed that?

I can't be racist –

How do you pronounce that?

Don't you get hungry?

Would you be offended –

I like spice.

They're probably related.

Uses Afro comb.

How do they run so fast?

No offence.

Is it virgin?

Aren't they the same?

Is that how you say it?

Is it like a Brillo pad?

Why can't I say that?!

SCENE SEVEN

(Pause.)

COREY *(Beat.)* What's the opposite of misogyny?

AMARA Man-hating, you mean?

COREY The word for it, yeah.

AMARA Don't know.

COREY You see.

AMARA What do you mean?

COREY If we don't even have a word for it, how can we talk properly about of all this?

AMARA *(Beat.)* Right.

COREY You're not hearing me.

AMARA It's not even – it's not the same, alright. It's like, I don't know – some black folk's aversion to – or, ill feeling, yeah, to white people.

COREY Yeah? There's a word for that.

AMARA It's not.

COREY What? Racism?

AMARA No.

COREY You've lost me.

AMARA I'm not saying it's right.

COREY It sure sounds like it.

AMARA It's just not the same. It doesn't have the same quality, the same violence – the total power to destroy another human being.

COREY It all sounds pretty convenient to me. I mean, that just leaves you totally immune to any form of criticism.

AMARA That's simply not true. *(Beat.)* Look. I don't hate you.

It's about choice – about a woman's right to wear and do whatever she wants.

COREY I agree – totally. That's why I'm baffled when I see Aisha, and others like her – with all the freedoms they've been afforded here – wearing the headscarf.

AMARA Yeah, I get that – and I doubt, deep down, if she really wants to either. I don't believe generations of women fought and died to see their sisters choosing to cover themselves up. Sexual liberation is still at the heart of the struggle, for me – the battleground remains on bodies – our dishonorable, deceitful flesh.

COREY *(Smiling.)* [...]

AMARA But it's their choice still – not yours – or mine. And we should respect that.

COREY God, you're amazing.

AMARA [...]

COREY And so beautiful.

You could do anything you want.

AMARA I know, yeah.

COREY I know you do. I'm just saying –

It would be crazy if you chose to hide yourself away.

(Beat.) You know?

AMARA [...]

It's about consent, Corey.

COREY [...]

AMARA It's got nothing to do with shame.

You need to recognise that.

SCENE EIGHT

The classroom should be set up to look like a visiting author has come to give a talk, and maybe read from their book. The audience should be well-behaved and sat quietly at their desks, in chairs or on the floor – while HECKLER should be planted amongst them. HANEEN should be played by a BAME actress. This scene is not entirely naturalistic – the actors speak in voices that do not belong to them.

GIRL Good evening everyone. This is our first guest speaker event of the semester. We're blessed to be joined tonight by Haneen Munir, who's just published her second smash hit 'From Libya to Labia: One Woman's Journey to Sexual Liberation'. Haneen describes herself as a forward-thinking, revolutionary Muslim feminist activist reformer. Her previous publication persuasively outlines her view of the violent nature of the hijab and aggressive female repression in Islam. She is also making waves online. Her recently launched YouTube channel already has over a quarter of a million subscribers – tuning in for her weekly videos.

HANEEN Thank you. My most recent book expands on this very idea of the Muslim female's sexual identity. Mia Khalifa, a Lebanese-born porn sensation – the subject of my video this week – has received a barrage of abuse – death threats, after she appeared in one of her films wearing a hijab. The gesture she made was a brave one – and should be commended for inspiring young Muslims to take control of their own bodies and sexuality. The toxic mix of religion and culture has become a catalyst for a deep-rooted sense of shame, leading to unbridled oppression in Islam. We need a social and sexual revolution – *(Beat.)* I'm going to ask you a question now – and

I want you all to be completely honest. *(Beat.)* Who of you here has ever masturbated? *(Beat.) (HANEEN raises her hand.)* I had pleaded with myself to leave any preconceptions to one side, but – unfortunately, this is the exact response I'd expected. Because ladies, the lack of raised hands, as trivial as it may seem, is an indicator for a much wider issue. You're trapped under Islam – and without reform – or a total revolution – you'll remain that way. It may seem to you that there's no way out. However, I pose to you a solution. As I say in my book, misogyny clearly lies on a global spectrum. I belong to many, many Muslim feminist reformist activist collectives, which look at ways to actively reinterpret the religion in a feminist reformist way that doesn't seek to oppress women. *(Beat.)* We can change things, ladies. Do you want to be part of an outdated religion that keeps women oppressed? *(Pointing to the front row.)* Do you? You? *(Beat.)* Why do we let an outdated religion force a woman into living a specific way, covered, sexless – an object of male desire?

HECKLER What about female desire? Don't forget the lesbians.

HANEEN It's even worse. *(Beat.)* And I speak about this in my video – religious customs bleed into the laws and cultures of the region. The horrendous practice of FGM enacted by Muslims across the world – the forced removal of young girls' clitorises /

HECKLER / I've still got mine.

GIRL Sorry. This isn't a Q&A /

HANEEN / No, it's okay – I'm not scared of debate. Yes, you've got yours – great, well done. But this isn't just about you. You need to think about the bigger picture.

HECKLER There's at least a billion Muslim women. To talk about FGM isn't to talk about Muslim culture /

HANEEN / You're clearly well-educated, but you have no idea what it's actually like to experience the world outside of your

safety net – like I have. I have lived the life of an oppressed Muslim woman – and actively chose to leave it behind.

HECKLER And you aren't better for that. It's not some filthy habit. It's a faith. You haven't given up smoking.

HANEEN Look, you clearly don't know what it's actually like to live under such conditions. There's an earlier video in which I talk the sexual abuse I experienced growing up in Egypt.

HECKLER This is irrelevant. It sounds bad – and I'm sorry for you, but you can't just use that to justify your flimsy arguments.

HANEEN You can be as facetious as you like, but people watch my videos – and more importantly, they're effected by them.

HECKLER Misogyny is a global problem. It's not like it's exclusive to Islam.

HANEEN No, it's ingrained in Muslim culture. And what's worse, we, who call it out in Arab countries, are labeled Islamophobic. *(Beat.)* It's ridiculous.

HECKLER What do you mean by Muslim culture?

HANEEN Well, if you watch my videos, you'd know. Millions of women – not just Muslim women – are forced to wear a hijab, forced to undergo female genital mutilation – if that doesn't make you feel something, make you realise /

HECKLER / Of course I understand /

HANEEN / No, you don't. The horrific mutilation of women isn't just a statistic in an argument. It's real. It happens every single day – and it's rooted directly in Islam.

HECKLER Once again you've attributed something cultural to my religion. FGM predates Islam. What's the fucking point of discussing this with you if your only tactic is shock sensationalism?

HANEEN Yes, it predates Islam – but it's only one of a long list of ways in which Islam oppresses women.

HECKLER Women are abused everywhere. Is there a country where no wife is beaten by their husband?

GIRL I think we're /

HANEEN / I made a video /

HECKLER / I really couldn't care less. That beating doesn't somehow hurt more if you're wearing a hijab.

GIRL I'm sorry. I'm going to have to cut you there. We're running out of time – and I really do think we've got off topic.

HANEEN I'm sorry we couldn't discuss this more, but please subscribe to my YouTube channel – comment, share, get involved. I've got lots of exciting projects in the pipeline, so stay tuned.

GIRL Thank you.

HANEEN Thank you. *(To HECKLER)* And thank you.

HECKLER *(Beat.)* What a cunt.

SCENE NINE

AMARA How amazing was she?

COREY [...]

AMARA Her energy – so infectious.

COREY *(Smiling.)* [...]

AMARA I mean, she was totally inspirational.

COREY She was pretty impressive, yeah.

AMARA Fearless, too.

COREY Her honesty.

AMARA She refused to pander –

COREY To apologise for –

(Beat.) And what she must have to deal with over there. I can't imagine.

AMARA The abuse.

COREY And more, I bet.

AMARA And to still be brave enough to talk about women's sexual desire. *(Beat.)* A proper role model, she is.

COREY A Muslim reformist. Who would have thought, right?

AMARA How did she put it again? *(Beat.)* A radical feminist Muslim. *(Beat.)* I loved her.

COREY *(Smiling.)* I can tell.

AMARA Sorry. I'm being a bit – I know. But –

COREY No, not at all. It's a surprise – she's a surprise. A Middle Eastern woman who –

AMARA […]

COREY You're beautiful, you know.

(Moving closer to AMARA.) Everything about you –

(Moving in for a kiss.) Your lower lip –

AMARA gently retracts herself.

AMARA *(Beat.)* Can you feel that?

COREY […]

AMARA *(Beat.)* There.

COREY What is it?

AMARA *(Getting on her hands and knees.)* Shhh.

COREY What you doing?

AMARA *(Placing the palm of her hand on the floor.)* That. Can't you feel it?

SCENE TEN

This speech should be performed by a white girl. She is non-violent and unassuming – with unwavering conviction. It should be absolutely clear – and ring out. She has an enraptured all-white audience of her peers. AMARA may agree with some of her points about Islam's relationship to women. She might even chime in.

GIRL Look, I know you're going to disagree, but I'm going to just put it out there, okay – 'cause it needs to be said. *(Beat.)* You can't deny that Islam, as a religion and a way of life, is inherently sexist. *(Beat.)* Right? And that's not me criticising all Muslims, 'cause obviously there's a select few who aren't – blah, blah. But a religion whose God expresses the need for women to cover themselves up completely can't be one that promotes equality. And the fact that women cover their hair because men see it as some sexual object is a clear example of this. Why don't men just blindfold themselves, huh? 'Cause they're the real problem. I don't see a chunky pair of eyebrows and feel like ripping my clothes off. It's ridiculous. Sexism is rife when it comes to female drivers, I know – we've heard all the jokes, but at least women can drive. We have this weird political correctness around the subject of Muslim abuse of women. People point blank deny it, and I know you'll disagree, but it's true. For 16 years, Asian men in Rotherham abused and trafficked over a thousand girls, and everybody knew – yet nobody did a thing because our own police didn't want to seem fricking racist. No-one wanted to admit to the fact that religion was promoting the abuse of these girls – girls our age, it's sickening. I mean, FG-flippin'-M, for Christ's sake. That's actually a thing – and it happens in Muslim countries, and yet people still have the audacity to sit back and deny

the misogynistic thinking of this religion. And it's no longer just in those backward, Stone Age countries, like Saudi Arabia and Yemen – it's spreading – it's now being brought here to Muslim communities in our own country. As many as 200 women were abducted by Boko Haram in Nigeria, and now 1600 girls are sold as sex slaves in Yorkshire. Yet people still linger on this illusion that Islam is a peaceful religion. How can that be true? Islam, fundamentally, its text, is a patriarchal religion, which relishes the idea of male dominance, female submission, paedophilia, child marriage, death for adultery, stoning of homosexuals, burkas, chopping off of limbs and basically the destruction of modern day society in an attempt to pull us back into the Stone Ages. If we're not careful, we'll be too bloody politically correct to stop a terrorist blowing up Buckingham Palace. "Oh, sorry Mr. Muslim man, of course you can go through security with that C4 strapped to your chest – wouldn't want to offend you, I'm not racist." So what if you think I'm racist. I can't sit back and let people justify the actions taken in the name of Islam. I'm not saying that Muslims at heart are inherently sexist, or want to gun down all infidels, but growing up reading the words of the Qur'an will drag anyone down into this pit of violence. And we're vulnerable. People our age are at their most susceptible, and we have to try and make people see the dangers in worshiping Allah – or else who's to say we won't get caught in the web and mindless march to Syria. And these dirty, violent men aren't some far away foreign boogeyman. The news isn't just a fictional horror movie to scream at and then justify the fear with the fact that demons don't exist in Britain – 'cause they're here, in fucking Yorkshire.

The same adult voice heard at the top of the show comes over the tannoy to tell everyone that the technical issue has been resolved, and that they can now enter the theatre. AMARA and COREY quickly, and silently, shepherd the audience to their seats.

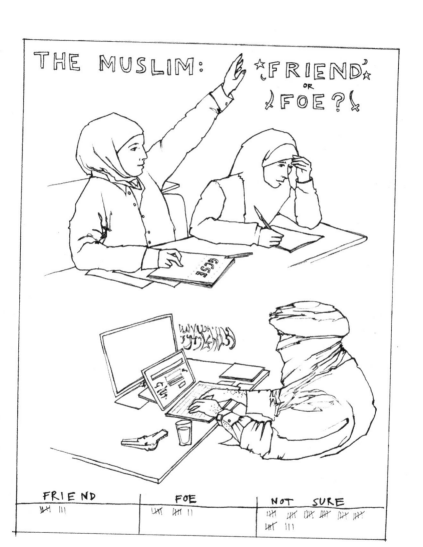

TOUR 2: MOHAMMED & DAISY

SCENE ONE

DAISY takes out her phone.

MOHAMMED What you doing?

DAISY Calling Farouk.

MOHAMMED I should have done the same, you know.

DAISY *(On her phone.)* What you on about?

MOHAMMED Dodged this stupid show.

DAISY Who told you that?

MOHAMMED What?

DAISY That he's /

MOHAMMED / He hated the fucking play.

DAISY You're chatting shit. He was just –

(*Beat.*) Fuck.

MOHAMMED Relax.

DAISY It keeps going straight to voicemail.

MOHAMMED Just leave him, man.

DAISY *(Texting.)* It's not like him, this. *(Beat.)* Aisha and Laila, too.

MOHAMMED He's probably in The Builder's Arms – having a cheeky pint.

DAISY If he is, I'm going to kill him.

MOHAMMED Forget it.

(Pause.)

MOHAMMED *(Beat.)* Should we?

DAISY Huh?

MOHAMMED You know, get out of here.

DAISY Where to?

MOHAMMED I don't know – anywhere. Just the two of us like.

DAISY Stop fooling around, Mo.

MOHAMMED *(Glancing at the audience.)* They'll be alright.

DAISY No, I said.

(Beat.) What's wrong with everyone today?

MOHAMMED Nothing. Jeez.

DAISY Come on, Mo. I told you last time – you can't just keep /

MOHAMMED / Alright. It was just an innocent – thought. *(Beat.)* So, you think they'll cancel the show then?

DAISY Don't know.

MOHAMMED Man, I hope so. *(Beat.)* I mean, this show – my role – it ain't going to get me into RADA now, is it.

DAISY [...]

MOHAMMED *(Beat.)* What? You think Chiwetel got into LAMDA playing roles like this?

DAISY Like what?

MOHAMMED Don't. *(Beat.)* You know exactly what I mean!

DAISY [...]

MOHAMMED Shit, I would have settled for some Dennis Kelly – Roy Williams even – over this crap.

DAISY *(Beat.)* Chiewetel.

MOHAMMED What?

DAISY Some posh boy from North London.

MOHAMMED A posh black boy still.

DAISY I'm not interested in all that. He don't represent me – you, maybe.

MOHAMMED And what?

DAISY Whatever.

MOHAMMED Hold on. You saying you're not a black actress?

DAISY No, that's –

(Beat.) Listen, I don't wanna talk about it.

MOHAMMED Don't get me wrong now – those two they got in to work with us are safe and all that. But still, we all know why they got them in.

DAISY And that's a bad thing, is it?

MOHAMMED It should always be about artistic excellence, right? *(Beat.)* Merit.

DAISY *(Beat.)* Yeah.

MOHAMMED If we end up –

(Beat.) Forget it.

(Pause.)

DAISY *(Beat.)* They called you back then?

MOHAMMED Not yet, no.

DAISY [...]

MOHAMMED You?

DAISY *(Beat.)* Yeah.

SCENE TWO

This is a proper choir, no matter the size. They should be uniform, formal and impressive. Whatever music you write to go with the lyrics, it must feel distinctly Christian, grandiose and stern.

La eelaha il lla la
Muhammaduh
Rusoo la

Oh ye
Believe
Allah heareth all

Oh Lord
My friends
Allah knoweth all

Lord of all worlds
Oh please
Oh please guide me

Guide us
On the
Straight path
O-all-mighty

La eelaha il lla la
Muhammaduh
Rusoo la

I hold out my palm to Islam, brothers
I hold out my palm to Islam, sisters
All you children of Israel, walk on
Come on walk to Mecca, with open palms

La eelaha il lla la
Muhammaduh
Rusoo la

Prophet
Open
Up our hearts and minds

We have
Sent you
To entire mankind

We've sent you with
Our truths
Not hiding

Muhammad
Herald of good tidings

Father are you fighting unbelievers?
Mother are you hiding, is sister too?
Brother are you fighting, don't deceive us?
Sister still hiding, where are you?

Allah
Oh ease
For me my task I've wronged

Oh Lord
Untie
The knot that's in my tongue

They'll understand
My speech

And join us

In the
Name of
Allah the most gracious
I hold out my palm to Islam, brother
I hold out my palm to Islam, sister
I hold out my palm to Islam, brother
I hold out my palm to Islam, sister

Islam!

SCENE THREE

MOHAMMED is humming along to Leon Bridges' 'Better Man'.

MOHAMMED *(Under his breath.)* I don't want much. I just wanna be a better man. I just wanna be – to my baby.

DAISY [...]

MOHAMMED *(Singing.)* Meet me off good luck. I was singing with them jezebels.

DAISY Seriously –

MOHAMMED *(Beat.) (Singing.)* Under perfume sheets. Got a golden smile, heart overflow. But got us in love, but it wasn't enough.

MOHAMMED starts humming the hook.

MOHAMMED begins talking to the nearest female audience member.

MOHAMMED *(To audience member.)* Enjoy that?

MOHAMMED responds to the audience member's reply and/or riffs off their reaction.

MOHAMMED *(To audience member.)* No – that's incredibly – I meant that – in there.

MOHAMMED responds to the audience member's reply and/or riffs off their reaction.

MOHAMMED *(To audience member.)* Pretty informative, right?

MOHAMMED responds to the audience member's reply and/or riffs off their reaction.

MOHAMMED grins at DAISY.

DAISY Whatever.

(Pause.)

MOHAMMED clocks a pretty white woman in the audience.

MOHAMMED smiles at her.

MOHAMMED *(To audience member.)* Hey. How you doing?

MOHAMMED responds to the audience member's reply and/or riffs off their reaction.

MOHAMMED *(To audience member.)* You here alone then?

MOHAMMED responds to the audience member's reply and/or riffs off their reaction.

DAISY Mo.

MOHAMMED Yeah, what do you want? Can't you see – I'm busy.

DAISY What you doing?

MOHAMMED Nothing – chill, yeah.

(To audience member.) So, what's your name, lovely?

DAISY Oh, my days.

MOHAMMED *(Kissing his teeth.)* Stop trying to dead my style.

DAISY You're embarrassing yourself.

MOHAMMED And you're killing my vibe here.

DAISY *(Looking at audience member.)* She's old enough to /

MOHAMMED *(Smiling knowingly.)* / Yeah, I know.

DAISY *(To audience member.)* I'm really sorry about him.

DAISY responds to the audience member's reply and/or riffs off their reaction.

MOHAMMED God, you're all the same – so fucking uptight, man.

DAISY What you saying?

MOHAMMED Mixed race chicks.

DAISY *(Beat.)* Really? You wanna do this – right now?

MOHAMMED Yeah, why not? *(Looking at audience member.)* You've already ruined my evening. So –

DAISY What?

MOHAMMED Why won't you go out with me?

DAISY I've told you a million times already – I've got a boyfriend.

MOHAMMED That's not what I mean. Why won't you go out with no brother?

DAISY *(Laughing.)* […]

MOHAMMED Why you laughing?

DAISY Nothing.

MOHAMMED No, go on.

DAISY Farouk ain't exactly white now, is he?

MOHAMMED That don't make him black though.

DAISY Says the brother flirting with some random white girl.

MOHAMMED I knew it.

DAISY What?

MOHAMMED You just can't handle it when the spotlight's not shining on you for once.

DAISY Yeah, and brothers can't handle a strong black –

(Beat.) You're all fucking hypocrites, anyway.

MOHAMMED Hold on. *(Beat.)* Black girl – and you're calling me a hypocrite. You know, I'd love to get away with something like that – call myself a white dude whenever I like and – you know, lighten the load from time to time. That would be just swell.

DAISY What's that supposed to mean?

MOHAMMED *(Beat.)* When you're with Farouk are you that black chick you talk of – or just another sweet white girl?

SCENE FOUR

Chaos reigns. It is clear that there is no teacher in sight. All the desks and chairs have been cleared, pushed to the side. The kids are doing what they want. We enter the scene mid-battle. It is raucous, loud and overwhelmingly good fun. The whole group keep the energy up – they clap, snap their fingers, cheer and jeer. When insults are traded, they are cheered at for being sharp rather than taken (too) personally. MOHAMMED and DAISY are tempted to join in. You can perform as many of these raps as you like, in any order, but the scene must end with the last two raps – 'Muslim Boy to White Boy' and 'White Boy to Muslim Boy' – as written.

BLACK GIRL TO BLACK BOY Don't @ me / Matter of fact don't chat to me / Egos fatter than your stacks be / Actually see man acting like Kanye / Hop off your dick / Like the reaper, I got a couple of bones to pick / King died for black and white, hand in hand / Not for brown yout to act big, chatting gas like / "I'm still black, but I'm lighter than you, so imma piss on our culture like it's something I'm entitled to do" / Full lips, big tits, wide hips / On a light girl peng, it's the shit / On a white girl, let's just say / Kim's just a double K, with a triple, standard / When I see them in the DM, I'm fleein' / Check

yourself, your bullshit, I'm preein' / "You're pretty buff for a black girl" / Bruv, you see this fist in a tight curl?

WHITE BOY TO ASIAN GIRL Asians are cool, man / They don't do any harm / They always sort me out with a side order of naan / With pushy parents, they want them to go far / To be a doctor, better / To put a cast on a broken arm / But too soon find out that you can't put a cast on a broken heart / With your dreams that fell short / Only to be left in the past / Turned it to nightmares, clawed up like Freddy Krueger's arm

WHITE BOY TO MUSLIM GIRL Now, don't get me wrong, I'm not whiner or a whinger / Although, I am white and painfully ginger / Light this beat up with a match / With my rhymes, I'm gonna singe ya / I can't tell if that's burqa, a postbox or a ninja / I can predict that you'll tell me that my lyrics are still / Hair colour and complexion of a newly lit spliff / Gonna take you on lyrical tour de force / show you bland-ass southerners how we do it up north

WHITE GIRL TO BLACK BOY Now I know I may look like Snow White / But I'll show you a lightie can spit right / 'Cause I wanna talk about black guys / And we all know about their dick size / But your cock so bloodless it tastes like halal meat / And I know you're shit in bed while you're acting so damn street / You're running 'round, chasin' hoes / We all know how the story goes / You're going on about your niggas / But I can't, I'm a gold digger / 'Cause white girl's all about the money / So, if you want me – "uh, huh, honey" / Make the money, get the cunt / 'Cause we all know what white girls want

MIXED RACE BOY TO BLACK GIRL All you blacks are jealous, calling me lightie / But it's clear to me that we're the almighty / Caramel complexion, it equals perfection / We win the election, that's natural / Don't worry guys, I got issues, too / Fucked up hair / Confused emotions / Never know whether to listen to Kendrick or The Who / Listen, I'm not afraid to say my favourite album is Take Care / Finding a shade this

perfect is kinda rare / Inshallah, my darkies, you guys need to lighten up / These are things Michael Jackson understood / Tryna make dark skin sexy again? / Shut the fuck up and put down your pen

BLACK GIRL TO MUSLIM GIRL Race card is obvious / But we ain't what the problem is / My girl over here learning how to fucking slaughter kids / And rape the kids / And take the kids / Before she says, "I'm sorry, but I ain't never gonna associate with a Muslim like Muhammad Ali" / Ain't got no jungle fever, nigga / Always got draw / Assalmu alaikum to the Nazis / Tell 'em all I like, y'all / 'Cause I ain't scared, believe me / Man grew up on road / Billin' cheese, getting wavy through my E3 postcode / Smoke all day, trust me, nigga / I barely fucking see you / But my missiles they can track / I wouldn't wanna be you

WHITE BOY TO BLACK GIRL You black girls all think you're pretty hard / But come to my yard and I'll break your heart / Trust me, I'm gonna be real fucking nice / Invite you over / Maybe stay the night / Bubble bath / Some candles / A bit of Barry White / That's right / I'm a gift, sent from up above / I'll even make small talk with your mum / And just when you're about to fall in love / I'll disappear and make you look dumb / "Why's he not text back for weeks?" / "Why's he on Insta kissing her on the cheek?" / "That's the place he took me for a treat" / So, that's when you come 'round my house / Make you a hot chocolate / Just the way you like / And you'll see / That I fucked you over / And white chocolate has you beat

BLACK BOY TO BLACK GIRL Take a Xanax / Stop rappin' rachet / Get onto white girls, bitch / Put down the hatchet and the horse hair from the packets / Matter of fact, you need to stop right there / I can't believe this crazy weave you're tellin' me is real hair / Shit, wallahi it ain't what it seems to be / I seen you creepin' behind the scenes / The team takin' turns with the bleaching cream / There, there / You moody 'cause you ain't as

thin as Cathy / Itchin' to talk shit n diss / Restless 'cause your skin is ashy / You're more pitch black than brown / Waited for these hoes to pipe up / Now, I'm swiftly bitch slappin' 'em down

MUSLIM BOY steps up. He moves through the group, delivering each cuss to the relevant person. He finally settles on WHITE BOY, who has been quiet throughout.

MUSLIM BOY TO WHITE BOY Watch the pasty little white boy @ me / You never rated me or my ancestry / Appropriate it all / Why don't you rob my family / More culture in my hair than your whole nation's history / We make the shit – then you abuse it / Now forgive me when I yawn through this cracker's unoriginal music / You a bitch and I can tell it / More criminal records on you than Akon records / Convicted for all that ignorant gang shit / You can't pass a test / But you can pass dat spliff / You know what, I'm actually sorry / 'Cause I know back there you get scraps, scars and sully / Last time, I smacked up a black yout / I don't need you to say it / There's a bill for my flow / So you gotta pay it / Imma get a flamethrower to fuck you up / Ain't nothing but pretty white girls who mad stuck up / I been around girls with big trust funds / Ain't nothing new / You just a lucky white bitch that was born to a Jew / Fuck a cheeky Nandos-looking bitch / Rolls with a side bag like he's even moving a ting / I'm insisting on an answer for this incest ting / Man will get with his sis and pop the kettle on / I'm bombing on this white boy / Call me Jihadi John

As WHITE BOY continues rapping, it becomes clear that a line has been crossed. The group gets quieter.

WHITE BOY TO MUSLIM BOY This Jew's nose is so big 'cause air is completely free / Hold on to your money / This kid's trying to steal your Ps / Collecting coins and notes like the banks are broken / If the world sunk that fat nose would keep him afloat / Black people, nothing new / I saw one last night / Trying to steal my damn television / I knew it was you 'cause I

saw your shit Jordans / But who'd you steal 'em off / 'Cause I know you can't afford 'em / Fuck you and your grandma, too / There's a banana boat outside / You know what to do / And Arabs / Don't get me started / You hog all the oil / That's why you're black hearted / Your dad's rich 'cause he dug a ditch / But when the sun goes down / Your mum's still his fourth, fifth, sixth bitch / Fasting when it's Ramadan / For the rest of the year your sister wants to bang a man / Sorry if I upset ya / I just hope you know how to get jizz out your sister's burka

MUSLIM BOY suddenly throws a ferocious punch – connecting square with WHITE BOY's jaw, knocking him to the floor.

The rest of the group rush to break up the fight, as the audience scuttle out.

SCENE FIVE

MOHAMMED Why they always got to – *(Kissing his teeth.)* [...]

DAISY [...]

MOHAMMED It's the same shit – over and /

DAISY / I can't blame him though. Man's a cunt.

MOHAMMED Yeah, I /

DAISY / Got what he deserved, I reckon.

MOHAMMED Yeah. *(Beat.)* I'm not saying he /

DAISY / *(Laughing.)* Sparked him proper good. *(Throwing a strong hook.)* Bosh.

DAISY swaggers back from the imaginary body splayed out on the floor.

MOHAMMED Having fun there, Nicola Adams?

DAISY I am, yeah. *(Putting her arms in the air.)* And the new –

MOHAMMED *(Holding DAISY's hand aloft.)* Slayer of racist –

DAISY Dunderheads.

DAISY and MOHAMMED both break out in laughter.

MOHAMMED Who says dunderheads anymore?

DAISY I don't know.

MOHAMMED You get though, that's not what people are going to see – to remember.

DAISY Maybe. *(Beat.)* Who cares?

MOHAMMED You can't say it don't matter.

DAISY It don't though. It's a struggle, understand – sometimes things need to get ugly.

MOHAMMED But if we lose the moral high ground /

DAISY / Fuck the moral high ground. That shit shifts whenever they want it to, anyway.

MOHAMMED But it's the only thing we got left. It's what helps us keep our heads held high.

DAISY Not me.

MOHAMMED I don't believe – I don't think you even believe /

DAISY / Black rage goes a long way.

MOHAMMED To where?

DAISY Sometimes your worst self is your best self. It's about shedding your skin – of slipping out of it, reborn – and free, finally.

MOHAMMED Nuh.

DAISY It's always been the case – from Brixton to Ferguson. They're all acts of shedding skin – bruised, beaten skin.

(Beat.) And now look – our rage is once again seen to be righteous.

MOHAMMED That righteousness is grounded in a long tradition of turning the other cheek.

DAISY Christian tradition.

MOHAMMED Yeah, so?

DAISY That's not the kind of bond I'm interested in.

MOHAMMED You don't have to /

DAISY / When they look at that brother in there, yeah. They don't see you – or me.

MOHAMMED Of course they do.

DAISY No, they don't. They see a Muslim – one fucked off Muslim.

MOHAMMED [...]

DAISY *(Beat.)* And there's nothing more unjustified to them than Muslim rage.

SCENE SIX

The audience happen upon BLACK BOY sat quietly, reading or playing on his phone – or tablet. MUSLIM BOY suddenly bursts in, visibly roughed up – a ripped shirt, smeared in dirt, grazes and a bloody nose. He practically crashes into BLACK BOY. He has only just managed to get away.

BLACK BOY What the fuck happened to you?

MUSLIM BOY *(Confused, out of breath.)* [...]

BLACK BOY Dude, are you okay?

MUSLIM BOY Fucking dickheads.

BLACK BOY starts dabbing MUSLIM BOY's nose with his shirt. He is a little too rough to start with – making MUSLIM BOY flinch. BLACK BOY finds a clean tissue in his pocket.

BLACK BOY Take this.

MUSLIM BOY *(Wiping his nose.)* Thanks.

BLACK BOY Stick it up each nostril – it'll stop the bleeding.

MUSLIM BOY rips the tissue in half, rolling each piece into a ball and sticking them into his nostrils.

(Silence.)

BLACK BOY Pussies.

MUSLIM BOY *(Beat.)* Pussies, yeah.

(Silence.)

BLACK BOY *(Beat.)* Who –

MUSLIM BOY Pussies.

BLACK BOY Why did they –

MUSLIM BOY [...]

BLACK BOY It's alright – they're gone.

MUSLIM BOY Fuck knows. Because I'm a terrorist.

BLACK BOY [...]

MUSLIM BOY *(Beat.)* Look at me. Why do you think?

BLACK BOY Yeah. *(Beat.)* So, are you –

MUSLIM BOY Am I?

BLACK BOY Muslim.

MUSLIM BOY Huh?

BLACK BOY I mean – I've seen you drink.

MUSLIM BOY Yeah.

BLACK BOY Not that it matters. It wouldn't matter. Brown enough.

MUSLIM BOY Yeah, they don't give a fuck if I – eat pork, or how many times a day I pray.

BLACK BOY I hear you. They don't chase me no more – black folk are sexy now.

MUSLIM BOY So, they need someone new to dick on.

BLACK BOY The media /

MUSLIM BOY / Fuck the media.

BLACK BOY I'm just saying, those racist dickheads just use you – I mean, I had that shit with – whenever, like, things happen.

MUSLIM BOY Things?

BLACK BOY You know – like, attacks. When shit happens, I just hope it's some crazy ass white dude. Because I know, if it ain't /

MUSLIM BOY / It'll be fuck Islam this, fuck Islam that. What must be hard is knowing who to discriminate against.

BLACK BOY What do you mean?

MUSLIM BOY Like, I'm mixed.

BLACK BOY May even get away with being just a tanned white guy.

MUSLIM BOY Right.

BLACK BOY They don't know what to make of you. So, you're saying they've got to –

MUSLIM BOY Yeah. I remember sitting in a Subway one time, and there's this guy, sitting maybe two tables away from me. I remember he screwed at me. He was, like – he kept staring at me, and finally he looked at me and said, "What are you?" And I was like, "What do you mean?" He fell silent for a moment – then he was, like, "Well, you're not black, you're not white – what are you?" And that's it for me – he doesn't know. He really didn't know.

BLACK BOY Why does it matter?

MUSLIM BOY Innit. But when the brother shouts Allahu Akbar just before /

BLACK BOY / Yeah, but all those 9/11 guys were in a strip club the night before.

MUSLIM BOY Exactly. Look, like the mass killers, like the white guys in Columbine –

BLACK BOY Well, that's the thing –

MUSLIM BOY Fuck religion. They're all looking for glory.

BLACK BOY In all the wrong places.

MUSLIM BOY Right. When a white guy goes in and blows shit up, it's always, like, "Oh, he had mental problems. He went off his fucking medication." But if a Muslim dude does the same shit, or a Middle Eastern guy, and yells out, "Allahu Akbar" /

BLACK BOY / Suddenly it's Islam. Islam's the problem.

(Silence.)

MUSLIM BOY *(Beat.)* What you got now?

BLACK BOY Chemistry.

MUSLIM BOY English.

BLACK BOY You feeling better?

MUSLIM BOY Yeah.

BLACK BOY You sure, cuz – I can take you to /

MUSLIM BOY /Nuh, I'm fine.

BLACK BOY Easy.

MUSLIM BOY stands up, pats his pocket and offers BLACK BOY a fruit gum.

BLACK BOY *(Taking one.)* This shit is my crack.

MUSLIM BOY It's just fruit gum, man.

BLACK BOY Nah, nah – it's my shit.

MUSLIM BOY You're, like, the whitest kid I know.

BLACK BOY Yeah, and this white kid needs to teach you how to take a punch without being a pussy.

MUSLIM BOY I could take you any day.

BLACK BOY Don't tempt me.

SCENE SEVEN

DAISY *(Beat.)* You know when people try to –

MOHAMMED Qualify their racism.

DAISY Yeah. Exactly.

MOHAMMED "I'm not a racist, I'm –"

DAISY "Married to" – whatever. "My best friend's –"

MOHAMMED Yeah, yeah.

DAISY Well, it's the same. *(Beat.)* With Islam now. *(Beat.)* How many time have you heard people say, "I've got nothing against Muslims, it's Islam I hate."

MOHAMMED All the time. You should hear some of the shit my mum comes out with. I was telling her about the play the other day, and she just went off on one.

DAISY Love the sinner, hate the sin.

MOHAMMED It comes down to acts motivated by hatred. That's all that matters.

DAISY What was that shit Corey posted on Facebook?

MOHAMMED What? That repost, you mean?

DAISY Yeah.

MOHAMMED It was some American radio talk show host.

DAISY Right, he was talking about creating these identifying markers.

MOHAMMED Of making Muslims wear armbands – crescent moon armbands. If we ever needed to round them all up. Madness.

DAISY And didn't Corey try and defend it by saying it was ironic – some clever joke or something that we just didn't get?

MOHAMMED *(Laughing.)* Yeah, yeah – you're right, he did.

DAISY All those likes.

MOHAMMED From classmates.

DAISY I know.

MOHAMMED And the comments, jeez. Those weren't parodies of shit, my friend.

DAISY Why do you think I don't talk to Isabella no more?

MOHAMMED Oh, for real. Who would have thought? Cute little Isabella – all pigtails /

DAISY / And pencil skirts.

MOHAMMED and DAISY start laughing.

DAISY Seriously though – how's that any different from what we have to deal with, huh?

MOHAMMED It ain't.

DAISY We get it's not a race, but you can't deny Muslims have been racialised – demonised and totally othered.

MOHAMMED I have to say –

DAISY [...] Some days I just wake feeling grateful. Grateful that the spotlight ain't on me no more – ain't on my little brother. That finally some other poor fucker's got to sit in that hot seat for a bit.

MOHAMMED When I'm on that bus home with Farouk after school – it's the only time I fit in with everyone else – the only time people ain't got their gaze set on me. *(Beat.)* It's horrible – wrong. I know. But I can't stop feeling it sometimes.

SCENE EIGHT

The classroom is set up for an interview – either the audience or other students are spectators. Maybe there are lights pointed at the interviewing chairs, to give the feel of a live television set. It should feel interminable.

WHITE GIRL Hello, thanks for joining us today. I'm going to cut straight to the point, if you don't mind. How do British Muslim men justify treating women as second class citizens?

MUSLIM BOY That's actually a huge misconception about Islam – and the relationship both men and women have with it. Many female Muslims in the country feel incredibly empowered by their religion and have gone on to do great things with the continued support of their religious communities.

WHITE GIRL That's fine – however, how can you ignore the fact that 99% of women in Egypt have been sexually harassed? Isn't it symptomatic of a religion which trains young women to be content with lower status in society?

MUSLIM BOY But sexual violence is a widespread problem in the majority of countries, regardless of culture or religion. One in five women in this country will be sexually assaulted. I don't understand –

WHITE GIRL I'm glad you brought that up, actually. The gangs of Muslim men in Rochdale are just another instance of sexual perversion in Islam. How can you defend that?

MUSLIM BOY That's a very specific case about a gang of young men – their individual perversions have nothing to do with Islam. Take the BBC in the '70s, Jimmy Savile, for instance, when is his religion ever cited as a cause for his perversion. I don't really understand where this interview is going?

WHITE GIRL May I ask you, sir – are you married? Have you ever been in a relationship with a woman?

MUSLIM BOY I don't see what that has to do with /

WHITE GIRL / Exactly my point. Young, sexually deprived Muslim men – due to the culture of repression in Islam – are led to assert their dominance in other more violent ways.

MUSLIM BOY I don't think those two things are even remotely related. That leap comes from ingrained Islamophobic views.

WHITE GIRL Oh, get over yourself. Just answer this question – do you feel sexually repressed as a Muslim man?

MUSLIM BOY What? *(Beat.)* Look, personally, I believe the perceived freedom of having sex with whoever you want is lustful. I have the freedom to choose who I love – and that's enough.

WHITE GIRL Answer the question. *(Beat.)* Do you feel sexually repressed?

MUSLIM BOY What has this got to do with your interview?

WHITE GIRL Do you feel sexually repressed?

MUSLIM BOY "Whoever among you is troubled by his sexual urge. Let him marry – for marriage causes the eyes to be lowered and safeguards the private parts." That is a verse from the Qur'an. Your prejudices are clouding this interview.

WHITE GIRL So, are you telling me you don't find any of our newscasters attractive?

MUSLIM BOY Look, I have the right to /

WHITE GIRL / Do you feel uncomfortable with the way young British girls dress?

MUSLIM BOY Not at all. It's a matter of values – and I know not everyone is going to agree /

WHITE GIRL / But you would view me as having loose morals if I choose to wear a bikini at the beach, wouldn't you?

MUSLIM BOY Look that's your decision /

WHITE GIRL / Are you blushing?

MUSLIM BOY Everyone has agency over their own actions.

WHITE GIRL Do you think you could be afraid of female sexuality?

MUSLIM BOY As I said before – there are many powerful women within Islam. Your argument is falling apart with these personal attacks.

WHITE GIRL Or women in power, perhaps?

MUSLIM BOY You're being ridiculous now.

WHITE GIRL I think you're sweating.

MUSLIM BOY I'm not sweat /

WHITE GIRL / Are you threatened by what I'm wearing right now?

MUSLIM BOY As I've said – you have the freedom /

WHITE GIRL / Do you find me attractive?

MUSLIM BOY I'm not answering that question.

WHITE GIRL Do you find me attractive?

MUSLIM BOY [...]

WHITE GIRL Do you find me attractive?

WHITE GIRL repeats this refrain for as long as possible. MUSLIM BOY remains silent. With this standoff never finding a resolution, the audience leave.

SCENE NINE

DAISY What a bitch. The way she bated him.

MOHAMMED Yeah.

DAISY And that – that smirk at the end.

MOHAMMED [...]

DAISY You see it?

MOHAMMED Yeah, I did.

DAISY It was so gross.

MOHAMMED I know.

DAISY Unreserved hatred – the kind only white people are capable of.

MOHAMMED [...]

DAISY *(Beat.)* Mo.

MOHAMMED [...]

DAISY Mo, you alright?

MOHAMMED Yeah.

DAISY You sure? You don't look it.

MOHAMMED Yeah, I'm just, uhm – tired.

DAISY [...]

MOHAMMED You know?

DAISY Yeah.

MOHAMMED *(Smiling.)* [...] Can we just walk, uhm – in silence?

DAISY *(Beat.)* Sure, Mo. Of course we can.

MOHAMMED It's so much easier without words sometimes.

DAISY *(Smiling.)* [...]

MOHAMMED *(Smiling.)* [...]

SCENE TEN

A room with chairs in a perfect grid. Each chair has a student stood on it. They stand in silence as long as is bearable – and then a little longer. It feels awkward. Without a signal, they all jump straight into a sitting position, in perfect synchronisation, except for those participating in the scene. Those

speaking start by standing on their chairs, but eventually they may move around as they see fit.

WHITE BOY It's the fact, the fact that they are capable of beheading our citizens on our soil.

BLACK BOY Yeah, well /

WHITE BOY / I don't – well, can't feel safe in my own back garden /

BLACK BOY / He was British.

WHITE BOY What?

BLACK BOY Michael Adebowale was British.

WHITE BOY He was a Nigerian Muslim –

BLACK BOY *(Laughing.)* He's a black guy living in London. Jesus, he was born in Lambeth – grew up in Romford.

WHITE BOY He murdered, brutally murdered a member of our Armed Forces – I mean, that's a terrifying fact.

BLACK BOY I'm far more scared of my own country, in the sense that, I guess, I'm a victim. I've always been a victim of institutional /

WHITE BOY / What?

BLACK BOY Institutional racism – like you all think that this shit isn't a thing anymore, man. Racism hasn't gone anywhere. It hasn't disappeared. It's just, it's not the same as it was when my dad was my age, but the cards are dealt the same.

WHITE BOY Yeah, but things have progressed – things have gotten better.

BLACK BOY Sure, I mean, when my dad was 18 there was no fucking way he'd be a lawyer, but now there's like a 1-in-50 chance. *(Laughing.) (Beat.)* Look, why is it that when I'm walking down the street with my older brothers, who like to wear sportswear – they constantly get harassed by the police with stop and searches? Why is it that my man can't have his hair grown out in an afro, a high top – but in private schools,

all these white kids have short, back and sides. It's the same thing. I mean, marijuana – fuck, man. The nigga with the bag of weed in his bedside table – he's a criminal?

WHITE BOY So, you're not scared of being gunned down while like – I dunno – you're just enjoying a Frappuccino /

BLACK BOY / Look, fuck that, no. I'm not fucking scared of being gunned down – or blown up. I'm, look, I come from Peckham. I got threats from all sides. Man, if someone wants to fuck me up, they're gonna fuck me up. I ain't gotta think about the fact that when they're threatening me from a million fucking miles away – sending me a video of some dude fucking up yout in Afghanistan. They're in my neighbourhood. They're in my yard – and not only that, but I've got no-one to rely on. I'm scared of the police. I'm more scared of the Army. I mean, look here, man – you take away Islam from Michael Adebowale, and there's a black guy, a British black guy who killed a member, a white member of the Armed Forces –

WHITE BOY I feel your point is getting lost –

BLACK BOY Because you want to talk about Islam. And I'm talking about the fact that two black men brutally murder an 'innocent' white man, and there's a public outcry. But Stephen Lawrence's murderers walk free – not only Stephen Lawrence, but the many black citizens brutally murdered for no other reason but their race. I mean, if you wanna talk about the injustices against unarmed black men and women in America, being beaten and killed by the police, I can /

WHITE BOY / That's beside the point – the police aren't there to be a threat /

BLACK BOY / Fucking hell.

WHITE BOY Six jihadis attack Paris – killing hundreds of innocent people. Six individuals causing all this damage, and you're telling me that you don't take the threat of ISIS seriously?

BLACK BOY Alright, let's talk about Paris. And I'm not condoning the attacks in any way when I say this, however, how is one expected to be a Muslim in Paris when – for example, a Muslim woman can't even wear her hijab in school.

WHITE BOY And a Christian their crucifix –

BLACK BOY A Christian not wearing a crucifix doesn't affect how she goes about her daily life. A Muslim woman, in most circumstances, being told she can't wear a hijab is her losing her dignity, her respect for herself. Countries like France push you into a corner – hiding your faith, feeling like you can't be proud of your own identity, like there's something inherently wrong with it – like the actions of a handful of extremists speaks for the whole of Islam. Or, in many cases, man turns to extremism – becomes radicalised – because they see no other way out.

WHITE BOY And this links back to being black how?

BLACK BOY It's an example of the exact same violence. To see a black man, to see a Muslim, in Paris isn't as a simple as getting on the fucking Eurostar and pulling up in the capital. Nah, man. You got to travel an extra hour and a half – to the outskirts of the fucking city to even see a person of colour. Race in Paris is pushed to the sides, quite literally pushed to the sides – banlieues hidden behind a façade of free speech that gives way to racism. Somehow mocking the Prophet is seen as acceptable – in the name of free speech. The French push us out of their tourist spots. All we have is this romanticised idea of Paris. We don't think about the undertone of racism and discrimination. Black culture – in the mainstream, it's depicted as one of pussy, money, guns and weed. When you turn on your TV, the news revolves around another black man being arrested – or fucking ISIS. You never see a fucking white guy on Cops. And black actors dream of roles like those in Kidulthood. I mean, why the fuck is that? People like 50 Cent – a poster boy for blackness. *(Beat.)* What you think?

WHITE BOY What? What do I think of? *(Beat.)* I think of – well, rap music. I think of a black man becoming successful.

BLACK BOY But to be a successful black man is to – in the public eye – is to talk about certain things, rappers – rappers like 50 Cent. It's all about guns, violence, you know? I mean, fuck – look at Obama. He achieved nothing. It's ironic – under his presidency there was a rise in police brutality against African Americans. It's the government. It doesn't make a difference. Western wars have killed four million Muslims – four million Muslims since 1990. More Western citizens die in traffic accidents than at the hands of terrorists, yet we slaughter their people in the hundreds of thousands. I can't think of a year when we weren't meddling in the Middle East. That's why the government is something I fear more than fucking ISIS, Boko Haram, the whole fucking lot of 'em. What makes it so scary is that we don't see – we don't see that we are victims of a fascist regime.

WHITE BOY Oh, come on.

BLACK BOY All of us – all of us are victims of a fascist regime run by white supremacists /

WHITE BOY / Jesus.

BLACK BOY No money for education – fucking over our kids. It's not just a race thing. It's class. Let's fuck over anyone who isn't of a certain stature, who doesn't come from money, which leaves the working class in the shit. And a fucking fair amount of the working class, it can't be ignored, are people of colour – which is agonising as the West stole us, and now steal from us. No money for the NHS. No money for low income homes. No money for disability benefits – but we have Paralympics every four years to make it look like we give a fuck. No money for public services. But we've got the fucking money to bomb Syria. We're all being fucked over for a war. We're all victims. We're all pawns in this game.

The same adult voice heard at the top of the show comes over the tannoy to tell everyone that the technical issue has now been resolved, and that they can now enter the theatre. MOHAMMED and DAISY quickly, and silently, shepherd the audience to their seats.

CHANGE COMES FROM WITHIN

TOUR 3: LISA & EDDIE-JOE

SCENE ONE

EDDIE-JOE is fiddling with his phone.

LISA [...]

(Pause.)

LISA *(Beat.)* I'm scared.

EDDIE-JOE [...]

LISA nudges EDDIE-JOE with a playful shoulder barge.

LISA *(Beat.)* Eddie.

EDDIE-JOE *(Staring into his phone.)* Huh?

LISA I said, I'm scared.

EDDIE-JOE *(Beat.) (Giggling.)* Yeah. Of what?

LISA *(Slapping EDDIE-JOE's shoulder.)* It's not funny.

EDDIE-JOE *(Still giggling.)* Yeah – no, of course –

LISA *(Punching EDDIE-JOE's shoulder.)* Stop it.

EDDIE-JOE *(Looking at LISA.)* Alright – fuck. Calm down. *(Shaking off his arm.)* I wasn't laughing at you. *(Beat.)* That hurt, man.

LISA Good.

EDDIE-JOE *(Beat.)* What is it?

LISA [...]

EDDIE-JOE What, Lisa?

LISA Nothing.

EDDIE-JOE You see, you're just gassing.

LISA Am I?

Farouk, Laila – and Aisha.

EDDIE-JOE Yeah?

LISA [...]

EDDIE-JOE *(Beat.)* What?

LISA [...]

EDDIE-JOE *(Beat.)* Don't.

LISA All missing.

EDDIE-JOE They ain't missing. They're just not here.

LISA Yeah, some coincidence that.

EDDIE-JOE [...] *(Beat.)* Say it?

LISA What?

EDDIE-JOE What you're thinking.

LISA [...]

EDDIE-JOE *(Beat.)* Go on.

LISA Nuh.

EDDIE-JOE Just say it.

LISA Nuh, I'm not having it. You're trying to catch me out – make me – I'm not a racist, alright.

EDDIE-JOE Fuck's sake. Farouk's a pussy. Laila got suspended last term for giving Callum head behind the bike shed. And Aisha – well, Aisha's with me, ain't she. So, what you scared of?

LISA *(Beat.)* And what about me?

EDDIE-JOE What about you?

LISA They're going to think I'm one of them.

EDDIE-JOE Them?

LISA Yeah – a Muslim.

EDDIE-JOE A Muslim?

LISA Remember when they attacked those Sikhs after 9/11.

People are fucking stupid, man.

EDDIE-JOE That's America though.

LISA And?

When hysteria settles in, there's no room for – you can't sit people down and just – you know, rationalise with –

EDDIE-JOE It's not the same here.

LISA Isn't it?

EDDIE-JOE In Britain, no. And London, I mean – *(Beat.)* Listen. Nothing's going to happen to you, alright.

LISA [...]

EDDIE-JOE Hey. Everything's going to fine. *(Beat.)* Yeah?

LISA *(Beat.)* Yeah.

EDDIE-JOE *(Beat.) (Opening up.)* Come here.

LISA curls up in EDDIE-JOE's arms.

(Pause.)

EDDIE Better?

LISA Yes.

EDDIE Alright then.

LISA [...]

(Pause.)

LISA releases herself – with the slightest hint of reluctance.

SCENE TWO

The audience are in a classroom for a few seconds, before the students start earnestly rehearsing or presenting their homework – Muslim heroes. They are desperate for an audience – or simply desperate to get it over with. Any actor can perform any of the presentations – doubling up, if so desired.

So – I kinda did what you wanted me to, but – didn't, exactly, do what you asked. But I did do something, so – yeah. **Kamala Khan**'s a fictional superheroine who operates under the alter ego of Ms. Marvel. Her comic books are published by Marvel Comics. In fact, she's Marvel's first Muslim character to headline her own comic book.

Khan's origins are that she's a Pakistani American teenager from New Jersey with shape shifting abilities – which is a whole other story. She decides to adopt the codename Ms. Marvel after her idol Carol Dawers – the previous Ms. Marvel, who's now Captain Marvel. The character was inspired after Marvel editors Sana Amanat and Stephen Wacker were listening to Amanat's anecdotes growing up as a Muslim American. Therefore, the series also serves – in Amanat's words – to explore the Muslim American diaspora from an authentic perspective. Her costume is influenced by the shalwar kameez, a traditional outfit originating in South Asia, and it looks sick, plus – if you've read the original Ms. Marvel comics – it's a whole lot less slutty, making her appeal more to Marvel's female readers – as a respectable superhero, and not just some sex siren. However, although they wanted the costume to represent her cultural identity, they didn't want her to wear a hijab, which is fine, but in my opinion, they missed out on a great way for her to conceal her identity.

Okay, so, like, **Monica Ali**'s a British Muslim novelist who wrote Brick Lane. It was shortlisted for the Man Booker Prize – and it totally deserved to win. It's like this really beautiful story about the life of the girl, Nazneen, who moves to London

at eighteen to marry this older guy, and they live together in Tower Hamlets. At the start, she speaks, like, no English, and the book looks at her – at her life and her adaptation to the Bangladeshi community in and around Brick Lane, as well as her relationship with her husband – who's kinda a dick. If you don't wanna read it, then watch the film 'cause Granta magazine named Ali one of the best British Muslim – no wait, best British novelists, sorry. Like, some of the Bangladeshi community didn't like it 'cause they felt like it stereotyped them and stuff. But I think that it's great that at least they get some representation 'cause they don't get their voice heard that much. And it's such a moving story that it makes up for it. It's just really nice.

Adeel Akhtar's the funny one in Four Lions. Not the fit one. Not the rubber dingy rapids one. He plays the one who gets blown up with a sheep. The one who wants to bomb Boots 'cause they sell condoms that make you wanna bang white girls. Born in London, he studied law, and fell into acting when he went to New York to help his girlfriend audition for drama school – taking a place himself. He's also a National Youth Theatre member. *(Beat.)* Since Four Lions, he's gone on to big things, playing roles with Sacha Baron Cohen in The Dictator – and Smiegel in the new Pan movie. In 2014, he was nominated for a BAFTA for his role in Channel 4's conspiracy thriller Utopia. He starred alongside Martin Sheen in the Young Vic's production of Hamlet – and he'll be in A Christmas Carol at the Noel Coward Theatre this December. I can't wait.

He's a pretty big deal, is Adeel. He's spoken out on the call for a review of the UK's terrorism laws after he was questioned at Heathrow – on a flight to JFK, where he was handcuffed by the FBI and questioned for nine hours. He shared the same name as an al-Qaeda suspect, apparently.

So, my presentation is on singer, songwriter and former One Direction member – **Zayn Malik**. Now, before I go any further, I'm not no One Direction fan. I don't buy tampons from Superdrug. I'm a Zayn Malik fan – and that's a 100% no homo. I mean, think about it. He became part of one of the most successful bands, was easily the best singer – and the best looking – again, no homo. He always stood out 'cause he had that one thing. Also, he dated Rebecca Ferguson, who is, like, in my top ten fittest MILFS. Then, he went on to date Perrie Edwards – the fittest member of Little Mix, and then dumped her for Gigi Hadid. If that's not upgrading, then I don't know what is. *(Beat.)* And he's from Bradford, which has a nice uni. So, that's alright. Most importantly, not only did he ditch One Direction at the peak of its success – he signed a mega deal with RCA soon after – where it's rumoured that Drake's gonna collaborate on one of his records. Hashtag JewishMuslimFlames – take that Israel. Plus, despite being a Muslim, he's constantly attacked by conservative Muslims for being contradictory – for practicing transcendental meditation, which is good for me, so – leave Zayn alone.

Yusuf Islam, probably known to most of you as Cat Stevens, began his musical career in the 1960s. He already had successful chart hits by 1967. However, in 1968, the fast paced life of fame and celebrity made him vulnerable to contracting TB. This was the beginning of his spiritual awakening. His deep musical and spiritual shift was made manifest in his albums between 1970 and '74, where he was firmly established as the singer-songwriter of his generation. The transcendental beauty of his music made its sacred journey through the generations to touch the beards of so many young people through the medium of a Boyzone cover in the 1990s. Soon after, his life was once again swept under an ocean of uncertainty. No, literally – he almost drowned.

In 1977, after receiving a copy of the Qur'an, he quickly embraced Islam. He continued with music, releasing songs such as A is for Allah and The Life of the Last Prophet. After 9/11, Yusuf Islam used his voice to champion peace between the West and the Muslim world. Following this, in 2004, he was presented with the Man of Peace award by Mikhail Gorbachev, for having worked to – "alleviate the suffering of thousands of children and their parents, and dedicating himself to promoting peace, reconciling people and the condemnation of terrorism."

Akram Kahn's a British contemporary dancer who, through drawing upon his study of both Western and Eastern artistic traditions, has become one of the most influential and innovative choreographers working today. His unique and ever evolving style is rooted in his background in both contemporary dance and kathak. Kathak is one of the eight classical Indian styles. It can be traced back to the nomadic bards of Northern India in the third century BCE. The kathakas, or storytellers, who developed the form, lived solitary lives, travelling and giving musical renditions of epic poems – imbued with the mythology and spiritualism of the area.

It comes as no shock then that Khan's work is characterised by a strong sense of narrative exploration, with the performer embodying many roles and – qualia – within a single piece. An element of spiritualism is also evident in his work, both physically and thematically, as he engages with elements of ritual with a sensitivity brought about by his own faith in Islam.

Khan aims to deconstruct the esoteric, often elitist, world of contemporary dance through an emphasis on genre-crossing collaboration with such names as Anish Kapoor, Danny Boyle and Kylie Minogue. In 2012, audiences around the world saw Khan and his company perform in the climactic sequences of the Olympic opening ceremony – inspiring many young dancers – and Muslims – around the world.

Zainab Badawi's really cool 'cause she's famous – like, she's on TV and stuff – almost like a celebrity, but she's not a stupid bimbo. She's really smart. She was born in Sudan, but she's lived in Britain since she was two. It's no wonder she's such a strong woman. Her great grandad pioneered women's education in Sudan. And her dad was a newspaper editor in Sudan – committed to social reform. She went to an all-girl's school in North London, which is kinda boring, but she then went on to Oxford, where she studied PPE – which is what all the politicians do. She's a bit of a British broadcasting queen. She's worked for all the major networks – including the BBC, Channel 4 and ITV. In 2009, she bagged an exclusive interview with Omar al-Bashir, Sudan's president and the first serving head of state to be charged with war crimes. She was apparently real feisty – and looked good doing it, too. It led to her winning International TV Personality of the Year. Oh, and on top of that she also managed to pop out four kids.

SCENE THREE

(Pause.)

LISA Deep that.

EDDIE-JOE I guess so.

LISA Fascinating, no?

EDDIE-JOE *(Beat.)* Yeah. You know what Ms. Jenkins is like though – proper right on about everything.

LISA [...]

(Beat.) I didn't know they –

EDDIE-JOE *(Beat.)* What?

LISA No, nothing.

(Pause.)

LISA [...]

EDDIE-JOE [...]

LISA I feel bad.

EDDIE-JOE [...]

LISA *(Beat.)* Yeah. I shouldn't have –

EDDIE-JOE *(Beat.)* What?

LISA [...]

EDDIE-JOE You shouldn't have /

LISA / How do you think I got one of the leads? I never get lead parts.

EDDIE-JOE I don't know. You –

LISA I told them I was Muslim?

EDDIE-JOE *(Laughing.)* Nice.

LISA [...]

EDDIE-JOE *(Beat.)* Seriously though –

LISA *(Shaking her head.)* I –

EDDIE-JOE Lisa.

LISA *(Beat.)* In auditions, I sold them this story about my brother – told them how I was sick and tired of stereotypical representations of Muslims in the media. I didn't think /

EDDIE-JOE / No, you didn't.

LISA Now it's Farouk, Laila, Aisha and – me.

(Beat.) They're going to arrest me, aren't they?

EDDIE-JOE Don't be stupid.

LISA Waterboard me – or something.

(Beat.) I should have known.

EDDIE-JOE What?

LISA That it never pays to be a Muslim.

EDDIE-JOE Wow. That's a /

LISA / No, I didn't – I meant /

EDDIE-JOE / It's okay.

LISA [...]

EDDIE-JOE *(Beat.)* I mean, you could always convert. It's super quick, I'm told. You just –

LISA [...]

EDDIE-JOE *(Beat.)* You're not a bad person.

LISA *(Beat.)* Yeah.

EDDIE-JOE You're not.

LISA Thanks.

EDDIE-JOE [...]

LISA *(Beat.)* You heard from Aisha yet?

EDDIE-JOE No.

LISA And you aren't worried?

EDDIE-JOE No. Look. I know how she looks – seems, you know – the headscarf and all that, but she's – cool. She's no different to the rest of us.

LISA Yeah – I know.

EDDIE-JOE [...]

LISA *(Beat.)* So, how long you guys been together?

EDDIE-JOE Almost a year now. Crazy. *(Beat.)* I remember how long it took me to ask her out. I wasn't nervous like. It was just – you know, I didn't know if they dated – if they were allowed to date, or if we needed a chaperone or something.

SCENE FOUR

The audience are in a classroom – if possible, sat behind desks. It has been silent for an uncomfortable amount of time. The door opens suddenly and three white girls glide in. They are perfect, unreal, angelic – well-pressed and glossy, identical as much as they can be. They are three little Lolitas. They take up a pose at the head of the class and talk directly to the audience without compunction or fear. The text is divided between them in any fashion, but they are one voice and sometimes speak in unison.

You live in a country consumed by a political establishment of smoke and mirrors. There is no real system of transparency or accountability – instead, the system of governance insists on disguising mistakes as metaphor and euphemism. The caliphate does not stand for this. Our system allows for the abuse of authority to be condemned – to be dealt with, accordingly. In 2008, 95 million pounds were claimed in expenses by your MPs. We call this theft. And the highest punishment given was a slap on the wrist. Under our system, such a thief would have their wrist cut off. This is what the people want. Our system allows for their voices to be heard. Such transparency is a quality unique to the Islamic State. Our citizens have direct involvement in our decisions. Those in your authority make decisions behind closed doors – and condemn all those who speak out against them, calling them terrorist sympathisers. Cameron spoke no words of apology – and no words of apology were forced on him. His accusations were left hanging, but in our just society, it would be him hanging. Our citizens' councils encourage dialogue between the ruled and our rulers. But you have a government 60 percent of the people do not want. They are silenced – oppressed by your rulers. What has democracy done for you? *(Beat.)* We are the manifestation of the will of the people. You condemn us for our violence – when, in fact, your violence is far more insidious. When we slice off wrists, we slice the wrists of sinful apostates. You, however, consciously give the innocent the

knife – to slice their own. Those who protest against your regime are found weeks later – dead in a forest. Our dead are buried in justice, with the confidence that a better and fairer state is being built. Your own ministers senselessly rape children under the pretense of homosexuality. This insidious behaviour riddles your society. It does not just plague your political system, but every aspect of your so-called culture. In the Islamic State, such behaviour does not exist. In your country, leaders of such cruelty remain comfortable in their buildings of power. In our state, they are rightfully pushed off them. And let us talk of how you treat the most vulnerable in society – your women. Our women are most prized – treated with upmost respect. They remain protected from the senseless noise and disgusting immodesty that is forced upon them under your culture. Despicable acts and misguided behaviour are celebrated – whereas in our society, women are shown the righteous path. If they refuse to see it, we take responsibility for them. We take responsibility for our elders – those who have raised us and shown us the correct path. You leave yours to die alone, locked up in abusive institutions, severed from contact with love. Who says that you, the West, have the monopoly on freedom? Your youth are disenfranchised, alienated and apathetic. They have become lazy. In the Islamic State, passion, determination and the potential for glory guide our young people. If they are ambitious, you saddle them with endless debt and lash punishment on their vulnerable backs when they cannot rid themselves of the burden you create for them. We – we reward ours. We encourage their fervour and desire to be educated – and reward it all with a place in paradise. You have no control over them. You cannot claim their loyalty. But they would die for us.

SCENE FIVE

LISA It makes me so angry.

EDDIE-JOE [....]

LISA *(Beat.)* And why?

EDDIE-JOE I know.

LISA Totally gross.

EDDIE-JOE Yeah.

LISA And so unnecessary, right?

EDDIE-JOE [...]

LISA *(Beat.)* No?

EDDIE-JOE Yeah, of course –

LISA [...]

EDDIE-JOE *(Beat.)* But – I mean, it depends on how you look at it.

LISA How else can you look at it?

 (Beat.) I don't understand why they'd choose something like that –

EDDIE-JOE What do you mean?

LISA What with everything other Muslims are having to deal with at the moment.

(Pause.)

EDDIE-JOE *(Beat.)* When you say other Muslims, do you mean –

LISA [...]

EDDIE-JOE I'm just –

LISA *(Beat.)* Funny.

EDDIE-JOE [...]

LISA Them, of course.

EDDIE-JOE *(Laughing.)* I know – I'm playing with you.

LISA *(Beat.)* I'm just saying it's kinda thoughtless – reckless even.

EDDIE-JOE It all depends on how representative – of an entire faith – you think those fools are, I guess.

LISA Yeah, but they've been given this – amazing – this rare opportunity to counter all the ugly representations in the media of crazed Muslims, and what – they do that –

EDDIE-JOE That shouldn't be their burden.

LISA It's still a responsibility.

EDDIE-JOE What? As Muslims?

LISA Yes – *(Beat.)* I don't know. As /

EDDIE-JOE / Those people exist, yeah – they haven't just made them up. They aren't straw men. They're real – and they're dangerous.

LISA I know that.

EDDIE-JOE So, what good does denying that do?

LISA I'm not saying we should ignore it.

EDDIE-JOE It's patronising.

LISA I just think they should be using the show to portray – you know, the vast majority of Muslims?

EDDIE-JOE The vast majority of Muslims?

LISA Yeah, all those who condemn such attitudes.

EDDIE-JOE I don't even – I just don't understand. What does that mean? *(Beat.)* What would such a thing even look like?

LISA I don't know – not like this.

EDDIE-JOE If that's what you want, they should have got some white dudes to work with us instead.

LISA I'm not saying –

EDDIE-JOE If anything, seeing those morons talk utter stupidness only serves to reinforce the fact the others are closer to us than to them. And that's gotta be reassuring, no?

LISA Yeah, I suppose.

EDDIE-JOE It shows up all these rumours flying around about Aisha, Farouk and Laila as pure hysteria.

LISA *(Beat.)* Yeah.

SCENE SIX

We are in a room full of visibly Muslim women – many wearing headscarves. At the front of the room is one student who is the only non-Muslim present. She has clearly been lording it over the other students for some time now. She might begin to notice tiny spurts of their growing frustration.

GIRL Let me just summarise what has been said before – forgive me for repeating. We've got to make them aware that the classification of hijabi women is instantaneous – and an instantaneous classification is an affective robbing of the chance to craft one's personal identity independent of Islam. It's such a shame, especially with all the exciting women in this room, that we're shut down before we can even broach controversial issues. It's noted – pre-considered, even – by the fact that we're Muslim – sorry, you're Muslim.

(Silence.)

GIRL *(Beat.)* Right. Rarely are we, women, given the chance to speak out. So, it's frustrating when that platform is dismantled by a pre-emptive decision on what our stance is, as independent free-thinking women. It's so heartbreaking. You just want to shake them until they just listen, but they have in their mind what we're going to say. They don't listen properly – and just assume our agenda.

(Silence.)

GIRL Naturally, people will lay blame at your door – for faults within your religion that aren't your fault – not in my name. We have to stand up to misrepresentations of women regardless of religion, regardless of race. We shouldn't notice race. We shouldn't notice religion. Women are women – and we need to fight for the right to be heard. Female empowerment is a struggle. As a woman, I've had to hear the critiques, often from white men, about the hijab. I say with my Muslim sisters that, like the tampon tax, this is not your fight. They tell us of oppression in the home. They tell us of oppression in the mosque. They tell us of the oppression in every inch of society, but have they really ever experienced oppression? Let us tell them that they simply don't understand. As a woman, I've been and spoken to women in the Muslim world, and I believe it is imperative that we listen to their voices. That women of all colours and creeds talk about it because it is our conversation. It is both Femen's and Kurdish female freedom fighters' conversation. And let me tell you that many women not only don't feel oppressed, but are empowered by their cultural practices. Who among us, a group of female Muslims, could not feel more comfortable and supported in a female-only prayer room. Or feel more cherished and loved by having family members so invested in their safety? I'm not saying that everyone does. But those who do must not be silenced because it doesn't fit into our Western cultural narrative of female empowerment. They told me how they feel a deep connection to their cultural practices – that their choice to wear a hijab or dress modestly is the manifestation of their will, of who they want to be – but really, and I'm sure many of you will agree, it's so much more simple than that. *(Beat.)* Look at all the stunning hijabis here today. They feel beautiful, no doubt. We feel confident – and when we feel confident, we feel empowered. But it's not just about the hijab. We, in the West, don't have the language to embrace Muslim culture

and recognise how it empowers women. They call arranged marriage a form of grooming. They call the woman's role in the home misogyny. We need one language to make our world more connected. From the suffragettes to women in Tahrir Square, each woman must accept their duty to one another – to listen and understand their mutual struggles, but also their experiences of empowerment.

SCENE SEVEN

EDDIE-JOE I bet you loved that.

LISA Yeah, she's wonderful.

EDDIE-JOE Come on now.

LISA What?

EDDIE-JOE It was ridiculous.

LISA Because –

EDDIE-JOE They way she romanticised the whole thing – claiming the hijab as some kind of feminist statement. *(Beat.)* It's embarrassing.

LISA You don't think Muslim women could choose to wear it? Use it as a way to reclaim their bodies and have full control over it?

EDDIE-JOE No, I'm just saying that liberation isn't simply a question of choice.

LISA So, you can't see how wearing it resists the commercial imperatives that construct women as both merchandise and consumers – like cars, beer and computer games?

EDDIE-JOE Jesus. What have you been reading? You sound like a fucking audio book.

LISA Thanks.

EDDIE-JOE No, I don't. Firstly, let's not fool ourselves into thinking that many women aren't forced into wearing it.

LISA Many?

EDDIE-JOE Yes.

LISA And you know this – how exactly?

EDDIE-JOE Come on now. *(Beat.)* Who would honestly wear it out of 'choice'? What does that even mean?

LISA That some women find empowerment in rejecting the idea that they should be reduced to their sexual allure.

EDDIE-JOE I just don't buy it. This idea that by wearing the hijab these women – and their presumed modesty – fly in the face of capitalism. It's total bollocks. *(Beat.)* You should see some of Aisha's mates – with their designer handbags, skintight jeans and branded hijabs.

LISA And?

EDDIE-JOE My girlfriend wears one, remember.

LISA Don't kid yourself, Eddie. I mean, you thought you needed a chaperone to take her out.

EDDIE-JOE Clever. But it didn't stop me from being attracted to her, did it? Or her going out with me. This idea that Muslim women – Muslim women in hijabs aren't sexual beings – people honestly believe that all these women behave in a certain way. I mean, they're not going to go to a pub with a headscarf are they? They say. They're not going to stay out late with a headscarf. *(Beat.)* It's bullshit. All of it.

LISA Now you're just contradicting yourself.

EDDIE-JOE I'm not, no. I'm simply pointing out that, while you fetishise the hijab, I'm telling you that these women find ways to negotiate it – and get on with their lives. This empathy, pity,

really, that white women – white liberal women get off on – that's the real problem here.

LISA I'm a white woman now.

EDDIE-JOE *(Smiling.)* [...]

LISA Don't even –

EDDIE-JOE But you're taking on its narrative, yeah. You see it in the theatre all the time – the sniffling, the running mascara, the unwarranted standing ovations that always come with productions which feed that appetite – it's sick.

LISA That's kinda harsh, no?

EDDIE-JOE I'm just pointing out the obvious hypocrisy, that's all.

LISA Maybe.

EDDIE-JOE *(Beat.)* Look at you – I couldn't imagine you covering your hair – you know, as a Muslim, of course.

LISA *(Punching him in the shoulder.)* Stop it. You promised –

EDDIE-JOE *(Laughing.)* I know, I know. I won't –

Seriously though –

(Beat.) (Taking a loose strand of LISA's hair and carefully curling it around her ear.) It would be a shame.

SCENE EIGHT

The room is a mess. There is a table full of props, instruments, paints, food – whatever else. They have all been used on a Muslim girl, who we see bound to a chair. She is daubed in paint and covered in feathers. There might be words scrawled on the wall behind her – "Bitch", "Traitor", "Liar" etc. But it eventually becomes clear that she has been a willing participant. She is unafraid – unapologetic. The question remains – who did this to her?

MUSLIM GIRL I hate him. I hate him – what a dick. So, Melissa gets to suck Hugo's cock behind the ICT building, but I get grounded for having a beer at Stacey's party. Hugo said he fancied me and found my faith sexy, but obviously he prefers getting his dick sucked by some white girl – rather than the tenets of Islam. I mean, I don't even want to go near his dick, but I'd love the option, you know. "For any woman to be peaceful and prosperous, you have to institute the rule of God, or Sharia." Wanting to cut my clit off doesn't seem very fucking peaceful, dad. And who's prospering from this? Is it Malala – being shot in the head for going to school? *(Beat.)* Is it 200 hijabees kidnapped by Boko Haram? Or maybe, the brainwashed young girls going to become sex slaves in Syria? Yeah, Islam seems pretty great, dad. What a prick. How could I have helped it? I didn't mean to stain the car. I just – it wasn't my fucking fault. How do you expect a twelve-year-old to deal with something like that – being called impure. I don't care if mum said you were only joking, or whatever. Your words hurt. I used to look up to you – and you just – you wanna be a good Muslim – a good Muslim, yeah? And you want me and mum to be submissive, bending to your every will. *(Beat.)* Then start fulfilling your role as the man of the house and get a proper fucking job. You're redundant. Redundant. *(Beat.)* And don't even try it – you didn't lose your job because of Islamophobia or institutional racism. It's 'cause you're a shit fucking salesman. Now mum's the one having to support this family, put food on the table. *(Beat.)* So, maybe you should bend to her will, yeah? And how about this? How would you like your little Muslim girl if she was to suck every uncircumcised cock she can find in sixth form? How about she takes as many white cocks – let them fuck her and film her – then make you watch – her honour being torn apart. That'll make her impure. 'Cause in this fucked up religion, victims are treated like sluts. And you know what? I'm not gonna be your little fucking repressed hijabi bride. I'm not gonna spend the whole of my

life dealing with pathetic Muslim men's fucking egos. Fuck you – and fuck your violent religion.

SCENE NINE

LISA I can't anymore –

EDDIE-JOE [...]

LISA I just can't – where do they come up with some of this stuff – I mean, all these ridiculous statistics. And God, the relentless hatred towards men – Muslim men.

This idea of them as wife beaters, paedophiles or rapists – it's just everywhere.

EDDIE-JOE [...]

LISA And the way she legitimates it all – just because she's a Muslim.

EDDIE-JOE An ex-Muslim now.

LISA Ex-Muslim – whatever.

(Beat.) Seriously though. How does it not get to you?

EDDIE-JOE How do you know it doesn't? I just refuse to let it rattle me, that's all. You've got to pick your battles – treat certain shit with utter contempt.

LISA [...]

EDDIE-JOE To be honest, I wish I had some of that fire in my belly, but I just don't. You can fake it, I guess. But it's the kind of thing you either have or you don't.

LISA Do you think I'm faking it?

EDDIE-JOE *(Smiling.)* [...]

LISA *(Smiling.)* [...]

EDDIE-JOE I don't, no.

LISA *(Smiling.)* [...]

(Pause.)

EDDIE-JOE leans in and kisses LISA, softly.

LISA *(Smiling.)* [...]

EDDIE-JOE *(Smiling.)* [...]

LISA [...]

EDDIE-JOE What is it?

LISA [...]

EDDIE-JOE Lisa?

LISA Nothing.

 (Beat.) Isn't it hot in here?

 I'm super hot.

EDDIE-JOE Uh, not really, no?

LISA Jesus.

EDDIE-JOE Are you okay?

LISA God, I feel – like, jetlagged or something.

EDDIE-JOE Jetlagged?

LISA Yeah.

SCENE TEN

The audience step into the middle of a very heated argument. Clear sides have been drawn – and it is a full on slanging match. The two people arguing each have their own group of supporters, who are stoking the fire. The scene should be on the move, constantly.

WHITE BOY We've got to be able to criticise bad ideas, dangerous ideas – and reform them, also. Islam was a great civilisation once – a long time ago. But of late, what has it achieved? Christianity has changed and progressed. But Islam – Islam has stayed the same. It amazes me that since the Islamic world created time, it's gone and wasted it beheading people and stoning women. It doesn't take a first class degree from Cambridge to realise that Islam has stagnated – has regressed even. I mean, Muslims have gone from building some of the most beautiful and impressive buildings in the world to flying passenger jets into them.

MUSLIM BOY Jeez.

WHITE BOY Sorry?

MUSLIM BOY Haven't you bigots /

WHITE BOY / Look, I don't care if you boo me. It's my right as citizen to exercise my right to free speech.

MUSLIM BOY Fuck's sake – there it is.

WHITE BOY I have the right to say whatever I like. And Muslim need to stop victimising themselves – no one group is immun to criticism. It's about time Islam stopped receiving speci treatment and faced up to reality.

MUSLIM BOY What's your point? That it's our right to be able spew any kind of hateful nonsense?

WHITE BOY Look, Muslims don't experience discriminatio You only think they do 'cause they kick up such a fuss eve time. We need to be able to accept that we might not like wh we hear when our freedom of speech is exercised. But tha what it is – a freedom. People need to develop a thick skin something Muslims seem incapable of.

MUSLIM BOY And if you say something hateful – regardless your freedoms – you should be prepared to be called out it.

WHITE BOY You can't just renege on such freedoms when it doesn't suit you. But the real issue here is who seems to take offence. Christianity has been mocked and derided for years. As I said, Islam was great once, but it just hasn't moved forward. It's like why would you use Myspace when there's Facebook now? It's outdated. Look how much the world has changed – a black president, equal rights for women /

MUSLIM BOY / I'm not sure.

WHITE BOY Why do they get so upset about a bloody cartoon? *(Beat.)* It's because they haven't written or drawn anything of worth in the last seven hundred years. And it's this lack of development – this stagnation, which is creating such insecurity. It's a vicious circle 'cause this insecurity comes from the knowledge that what they practice is backwards. They fear being openly critcised – meaning they will never progress. This is the Muslim problem. I mean, it must be pretty fucking embarrassing having your only Nobel Peace Prize won by a sixteen-year-old. We need to draw the limits of freedom of speech as narrowly as possible.

MUSLIM BOY And where do we draw them? Where's the limit?

WHITE BOY As narrowly as possible. Denial is embedded in Islam. Religion has no privilege.

MUSLIM BOY You're standing there talking about privilege. You couldn't have it any easier. You only love freedom of speech because you have the privilege to have what you say listened to.

LISA Please. Just stop – just stop talking. Listen to yourselves. Can you hear how ridiculous you sound? Freedom of speech doesn't exist simply to let idiots throw insults at each other. It's for self-expression. You've hijacked it for you own ends – turning this debate into a popularity concert. It's sickening.

WHITE BOY Calm down, Malala. Don't get your knickers – or should I say, burka in a twist.

MUSLIM BOY Sorry.

LISA Can't you hear yourself right now? You hide behind freedom of speech so you can be a fucking racist. Look – you don't allow them to define their own identity, then present your own negative stereotype of their faith, then you mock it – 'cause you've made it ready for ridicule. And then you've still got the audacity to tell us how pissed off they all are about it. What kind of freedom is that?

The same adult voice heard at the top of the show comes over the tannoy to tell everyone that the technical issue has been resolved, and that they can now enter the theatre. LISA and EDDIE-JOE quickly, and silently, shepherd the audience to their seats.

TOUR 4: SHIV & NANCY

SCENE ONE

(Pause.)

SHIV […]

(Pause.)

SHIV Oh, man.

NANCY […]

SHIV I can – oh, I can feel it – *(Beat.)* Yeah, yeah.

NANCY What is it?

SHIV *(Rapping.)* That's it, turn the page on the day, walk away Wooooo. 'Cause there's sense in what I say. I'm forty-fifth generation Roman. So return to your sitting position and listen. *(Beat.)* Fuck.

NANCY Shiv.

SHIV *(Ripping off his tie.)* Mate, it's sooooo hot in here. I'm buzzing –

(Beat.) (Giggling.) Fuck me.

NANCY Shiv. *(Beat.)* Shiv – you need to /

SHIV *(Rapping.)* / My crew laughs at your rhubarb-and-custard verses. You rain down curses /

NANCY / Shiv /

SHIV / But I'm waving your hearses driving /

NANCY / Shiv. Shiv, stop it.

SHIV Okay.

NANCY [...]

SHIV *(Beat.)* Okay.

NANCY [...]

SHIV *(Beat.)* You got any gum?

NANCY [...]

SHIV Oh, come on.

NANCY *(Rummaging through her pockets and taking out a packet of gum.)* Here.

SHIV *(Taking five, six, seven pieces and stuffing them in his mouth all at once.)* Thank you.

NANCY *(Snatching back the packet.)* What is it?

SHIV Huh?

NANCY That's got you acting the clown?

SHIV Oh. *(Beat.)* Nancy.

NANCY What?

SHIV You want?

NANCY No – *(Beat.)* no.

SHIV You sure? I've still got a half on me.

NANCY [...]

SHIV *(Beat.)* Fair enough. Markie pussied out, you see – we thought it would be jokes going halves before the show. It's the only way we'd get through it.

NANCY I've enjoyed working on it.

SHIV Yeah, you would though.

NANCY What's that supposed to mean?

SHIV *(Beat.)* I don't get it.

NANCY What?

SHIV Why she'd just go with them like that. I mean, she's one of us, right? Loves it here. Farouk and – what's her face – I can see them fucking off to Syria. *(Beat.)* Miserable cunts. But Laila /

NANCY / You don't know what you're talking about.

SHIV Save your pity for someone who cares.

(Beat.) You know what, I'm glad this has happened.

NANCY [...]

SHIV *(Beat.)* We're so fucked. *(Beat.)* Not you, of course. Never you lot. But us, we always get the blame for their fuck ups – from the police, from white men in tailored suits, from little old ladies with their tartan trolleys – we're all the same to them – brown folk. I'm tired of it.

NANCY You say it like you're being tainted or something.

SHIV I am. I'm being besmirched. I mean, just look at the part they've got me playing.

NANCY Well, I learned a lot, I reckon. When have we ever been given the chance to talk about Islam like that?

SHIV I don't care though – I don't give a toss about religion.

(Pause.)

SHIV [...]

NANCY What's wrong?

SHIV Oooh.

NANCY What?

SHIV My stomach. I can –

NANCY Shiv. Not now. We've got /

SHIV (*Running his hand up and down his throat and chest.*) / I can feel it here. (*Beat.*) I'm going to be sick. (*Beat.*) Yeah. I'm definitely going to puke.

SHIV runs out, leaving NANCY with the audience.

SCENE TWO

This scene is supposed to be a game of your own devising. Ideally, it would take place outside, and one of the rules would involve a ball. It should be complicated, with unexpected rules, but the core must be asking questions and getting points for answering them correctly. It should be physical. The game does not start and finish with the scene.

Translated into Arabic, what does the word Qur'an mean?

Recitation

Built in the 10th century, where was the first ever physicians' training hospital established?

Baghdad

When was the first mosque in America built?

1933

When was the Islamic Golden Age?

8th – 13th century

Written in 1905 by Begum Rokeya, what is the title of her novel which depicts a feminist utopia – considered by many to be one of the earliest works of feminist fiction?

Sultana's Dream

Who translated Greek mythology into Arabic in 900 AD?

Muhmmad ibn Jarir al-Tabari

Where do Muslims believe the Prophet Muhammed ascended to paradise from?

Dome of the Rock

Who was the first person to introduce Arabic medicine to Europe?

Constantinus Africanus

When was the Umayyad dynasty?

660 – 750

The 'Luck of Edenhall' is an ornately decorated glass beaker from Syria. In which century was it made?

13th century

When did Britain become the first country outside the Muslim world to issue sukuk – Islamic bonds?

2014

In which year were the first verses of the Qur'an recited to Muhammed?

610

Many academic traditions – including the distinction between undergraduates and graduates – began at which Islamic university?

Al-Azhar

Containing detailed descriptions of over a 100 devices, who wrote the *Book of Ingenious Devices*?

Banu Musa

Which Persian poet and theologian famously compiled much lauded analysis of the metaphysics of mercy?

Maulana Jami

When was the first pharmacy opened in Bagdad?

754 CE

Which author and engineer from the C11th dealt extensively with the discovery of gun powder?

Hasan Al-Rammah

In which dynasty was civic and religious architecture established?

Umayyad

Located in Agra, what is the most famous monument of Islamic art?

Taj Mahal

In which centuries were Arabic works of alchemy translated into Latin?

C12th and C13th

SCENE THREE

NANCY is energised by what she has just seen. It has helped consolidate her white liberal do-gooding nature. So, as well as having to chaperone the group on her own, she is keen on sharing that enthusiasm with the audience.

The following questions (both rhetorical and open-ended) serve merely as prompts – they should be sharpened, extended and tailored to the specific scene they have all just experienced.

NANCY That was great, right?

NANCY responds to the audience member's reply and/or riffs off their reaction.

NANCY I love Ms. Holmes. She always – I mean, when do we ever get to see that side of Islam? Its peaceful, enlightened history. Never, right?

NANCY responds to the audience member's reply and/or riffs off their reaction.

NANCY It's all about ignorance, a lack of – recognition. If people just had the opportunity to learn – yeah, to understand – I think they would – and things would be totally different, don't you think?

NANCY responds to the audience member's reply and/or riffs off their reaction.

NANCY If we could all just –

SHIV enters.

SHIV's shirt is tucked in and hanging out of the back pocket of his trousers.

SHIV That was something else, that.

 (Beat.) So – what did I miss? *(Beat.)* Islam's reformation.

NANCY [...]

SHIV What? I was only gone /

NANCY / Shiv.

SHIV Yeah.

NANCY Your shirt.

SHIV *(Beat.) (Looking down at his bare chest.)* Oh – yeah.

SHIV takes his shirt and wipes the sweat off his chest.

SHIV Well, if they want some uncouth yout, then –

NANCY Jesus.

SHIV *(Putting on his shirt – inside out.)* Let's check out what's behind door number two then.

SCENE FOUR

We are in a classroom. All the students are white, except for a single black boy in the middle of the room. As the audience enter, the entire classroom snaps into line – except for the boy. He is angry (maybe at the audience), and he has had enough. He might begin to speak to the other students trying to distance themselves from him. His speech is direct, aggressive and controlled. As it goes on, he does whatever it takes to be heard.

BLACK BOY Oh, sir. It was just a joke, chill. But what part of what I said was wrong? We haven't won a war since World War II. Iraq was a joke – and don't even get me started on the money we paid for those local gangs not to kill our troops. Is that where the Help for Heroes money goes? 'Cause if that's the case, then I don't feel bad for not donating – that's not honourable, that's extortion. So what if I described our MPs as having the brain cells of an egotistical, fart crunching, retarded sloth – it's true. We've got a government with the power to put pressure on horrific regimes – governments that subjugate their own people – and they haven't got the common sense or decency to do it. Instead, they're focused on hypocritical attacks. *(Beat.)* No, don't try and argue with me, sir – because you know they are, and I'll tell you why. Spoiler alert, I included this in the essay you assigned us on Monday, so I'm giving you a preview. The bottom line is we're not at war with radical Islam – and as expected, my fellow classmates are heckling me with, "Oh, that's stupid, what you chatting about?" Well, no. "You know we're at war with those turd nuggets?" We're at war with people who don't give us what we want. "Oh, these Taliban countries and their Islamic regimes are so fundamentalist." We're not at war with radical Islam because we're standing in line, playing kiss-ass with these Saudi businessmen. So, don't stand there, lecturing me, sir. Don't look at me like I'm this angry, troubled young black man because I was bold enough to raise these issues. No, I'm not saying I have all the answers. I'm only 16. I ain't even

got the answers for Physics next period because I was knee-deep in a search and destroy mission on CoD last night. But I digress. At least I'm not pretending I've got the answers like everyone else does on BBC Parliament. It just sucks that we're not being responsible with our power. And another thing, I was surfing the Internet in IT – in-between watching Jimmy Fallon videos on YouTube – and I happened to read about how Burma is ethnically cleansing Muslim people out of certain parts of the country. And yet, I've read none of this in the papers – but everyone's losing their minds over the Queen giving a Nazi salute. *(Beat.)* No, sir – they're not covering it because it's an embarrassment. It's an embarrassment to our government because, soon enough, fools like us are gonna get smart and start asking – "Hey, they're so critical of one regime, why aren't they having a go at this other one?" It seems like if you act like a terrorist, but your weapons are sponsored by our government, then you're exempt. So, if Tommy No Mates over here pulls out an AK47 and blows my brains out, then he's a hero because he ended my dangerous rant in the name of our Nazi Queen. But if I pull out a piece – and I hold it sideways 'cause I know most of you can't comprehend a black man holding it any other way – and bust a cap in his bony white ass for insulting my mum, then I'm the bad guy. And why? 'Cause Tommy's daddy's a bigshot over at HSBC, which makes his family worthier than ours. The fact he's got blue eyes is just a bonus. Too real for you, sir? Isn't your favourite character Robin Hood? Didn't he steal from the rich and give to the poor? And I'm pretty sure he put a few arrows in people on the way, so doesn't that make him a terrorist, too? And yet, you can't get enough of him – and his green tights. Oh, you people are just hypocrites – massive hypocrites. When are we going to admit that money is the only true incentive for helping others? We all know it – even those retarded sloths in the House of Commons know it. All these political situations, like Burma, are happening as we speak, and yet no-one cares

'cause they don't see any worth in covering it 'cause companies like Sky and ITV gain nothing from covering a genocide against Muslims.

SCENE FIVE

SHIV God, he kills me. The whole thing makes me wanna –

(*Beat.*) Yeah, that's it – pop some –

(*Beat.*) (*Rummaging in his pockets.*) Where's the other –

NANCY No. Not – Shiv.

SHIV (*Still rummaging through his pockets – a little more frantically now.*) It's alright.

NANCY No, it isn't. You've already /

SHIV / Relax. If I'm going to have to listen to more sanctimonious shit like that for the rest of the evening, then –

NANCY Shiv – Shiv, please.

SHIV (*Emptying his pockets all over the floor as he goes through them – leaving a trail of personal possessions and rubbish behind him.*) Fuck's sake. I can't –

NANCY [...]

SHIV finally gives up.

SHIV [...]

NANCY (*Beat.*) Shiv?

SHIV (*Taking in a deep breath.*) It's fine.

NANCY Yeah.

(*Long pause.*)

NANCY I agree.

SHIV Yeah.

NANCY He was a little intense.

SHIV [...]

NANCY *(Beat.)* His manner, no?

SHIV *(Beat.)* That's not really my problem with him.

NANCY Oh. Right.

(Pause.)

NANCY So – what is then? 'Cause he was kinda spot on, I thought – his politics.

SHIV It's so transparent – his act. That whole radical chic shit.

(Beat.) Who does this dude think he's fooling with all his revolutionary posing?

He makes it all sound so simple, so black and white – and they fucking love that.

NANCY He came across pretty genuine to me.

SHIV Self-righteous, you mean.

He totally believes he's this – roadman rebel.

NANCY He's not afraid to say what he thinks though – what he believes.

SHIV Oh, please.

(Beat.) It's just that he scares you.

NANCY *(Beat.)* What you talking about? No, he doesn't. Why would he /

SHIV / He does.

But you don't say anything, for fear of – *(Beat.)* You see him as legitimating you in some way.

NANCY What?

SHIV He's proper real to you – noble like.

Intense, you said.

NANCY Yeah.

SHIV And what's that code for?

NANCY Nothing.

SHIV You're telling me you'd have the same reaction if it was some white dude saying it?

NANCY This is Shiv logic, is it?

SHIV *(Beat.)* It's the same with Laila.

NANCY Wow.

SHIV You bang on about this fascination – this newfound appetite to find out more about Islam, but when have you two ever actually spoken about it?

NANCY I don't know –

(Beat.) I know you've got a – how would you describe – unhinged, yeah, that's about it – this fanatical crush on her, but this is all a bit much.

SHIV Fanatical – nice. You still haven't /

NANCY / Why do we even have to – talk about it? That's not what our friendship's based on.

SHIV Just admit it – having her as a friend helps colour your pale, Middle England existence.

SCENE SIX

This scene can be performed by a minimum of two people – and up to as many as is available. It is important to embrace the standup spirit – the hurling of jokes must be aimed to make people laugh – rather than cringe. The jokes can be delivered in any order. You do not have to use all of them.

However it must be clear to all the performers that there are two intended audiences – Muslims and white liberals.

Muslim jokes

How many Muslims does it take to build a clock?
One – which is a pretty big achievement, but he's a Muslim, so he just gets arrested.

What did the Muslim capitalist say to the white socialist?
No more jokes about the profit.

What kind of car does a Muslim drive?
A Hissab.

What do you call a Muslim woman's bingo wings?
Hiflab.

How many Muslims does it take to fix the NHS?
A few million – and one white guy to take all the credit.

How many Muslims does it take to produce the Guardian?
Maybe one – and a whole load of white liberal guilt.

What's a Muslim's favourite band?
Qur'an Qur'an.

What does a Muslim shout when he ejaculates?
Osama Been Laid-en.

There should be a law against ugly Muslim women.
There is – Sharia law.

What's the difference between black coffee and a Muslim?
They're both bitter, but you don't have to worry about one of them burning you.

What do you call it when a Muslim takes off his shoes to go into a house of prayer?

Mosqui-toes.

What did the Muslim get at the airport?
Cavity searched.

Have you heard about the Muslim comedy show?
It bombed.

What did the Muslim do in Cuba?
Waterboarding.

What do Americans call Muslim children?
Collateral.

Why did the Muslim get on the plane?
To go on holiday, you racist fuck.

How many Muslims does it take to demolish a building?
19 – and a whole lot of jet fuel.

What's the most popular genre of films for Muslims?
Bomb-coms.

What do you call a terrorist rapper?
Muslim-shady.

Why is Mo Farah so good at running?
Because he's got good Mus-limbs.

Where does a Muslim go for a drink?
The Allahu Ak-bar.

What does a Muslim eat for breakfast?
Syria-l.

What do you call a dog with an extremist agenda?
A terrier-ist.

What do you call a naughty Muslim llama?
Islamabad.

How do you make Muslims cry?
Make them second class citizens.

What's a Muslim's favourite fast food chain?
Burqa King.

What do you call a terrorist on a diet?
Mu-slim.

What do you call a feminist in a hijab?
A feminist.

How do Muslims tell the time?
On a terrorwrist watch.

I asked a Muslim guy for directions, but he didn't speak
English – so, I had to ask him what HU SEE IN?

How do you make a Muslim homesick?
Rendition.

Did you hear about the Muslim woman who committed
suicide on a plane?
I guess she hadn't heard about jihad.

What did the Syrian child get for Christmas?
Bombed.

Have you heard the one about the three Muslims who walk
into a bar?
No, me neither.

What do you call a Muslim bride to be?
Underage.

What do you call a Muslim called Yusuf?
Yusuf.

Why did the Muslim cross the road?
To get to the other side.

What do you call a Chinese Muslim who likes to smoke weed?
Jee Ham Hi.

White liberal jokes

What do you call it when a white liberal sticks up for Islam?
Guilt.

What does a Daily Mail reader do when sat next to a Muslim on a plane?
They say fuck this, and ask to move seat.

And what does a Guardian reader do?
They order a cup of Darjeeling tea, find something they're allergic to, rub it all over their body to force a bodily reaction, spill their tea all over the seat – then wait patiently for the attendant to ask if they'd like to move.

Knock, knock.
Who's there?
A British value.
A British value, who?
I don't fucking know.

Why didn't the white liberal turn left?
Because they're always right.

Why did the white liberal cross the road?

To get to the Muslim on the other side, tell him he's a "real Muslim bruv", fist-bump him in front of the media, then quickly go and wash his hands.

How many white liberals does it take to change a lightbulb?
Two – and a Muslim for the Equal Opportunities Monitoring Form.

Tony Blair gets paid millions to talk about peace.
No, that's the joke.

What's the easiest way to empty a tube carriage full of white liberals?
Chuck a Muslim in there.

How do you make a white liberal cry?
Make them shop at Morrisons.

What do I call a white liberal?
Dad.

What happened to the end of this joke about white liberals?
Censorship.

Who's paler than Fatima under her hijab?
Those white liberals speaking on her behalf.

Who's more nervous than a Muslim man on the tube?
The Guardian reader next to him, pretending to be fine.

SCENE SEVEN

SHIV Ah, they smashed it.

NANCY [...]

SHIV What a dude.

NANCY What a waste?

SHIV Waste?

NANCY Yeah – wasted opportunity. They said nothing.

SHIV They said everything. *(Beat.)* And they were hilarious, too.

NANCY That's not enough. It can't be.

SHIV Enough?

NANCY Yeah.

SHIV Enough for what? They're a comedian.

NANCY With that platform – that privileged voice – and what do they decide to do with it?

SHIV Crack some great jokes.

NANCY At least say something meaningful.

SHIV What? Like Frankie Boyle?

NANCY No, they just don't have to be so smug – so intentionally ambivalent about everything – It's tired – tiring.

SHIV They're not though. That's not what they're doing. You've totally missed the point.

NANCY Really? Enlighten me then, Shiv.

SHIV I'm just saying, everything you're looking for is in there.

NANCY Right.

SHIV It is. It's just a matter of approach – tact, really. That's where the politics lies. Not in the rhetoric. Fuck the rhetoric. Any dick can say some shit. But where's the craft in saying it? *(Beat.)* Right? Where's the real marriage between art and

politics? And they've got it. It's exciting. *(Beat.)* I wish I was allowed to do something like that in our show.

NANCY I don't see that – any of that. And other people – most people – aren't going to see it neither.

SHIV Fuck other people.

NANCY Your audience, you mean?

SHIV Yeah – a healthy disdain. It's good. It's important to keep that relationship honest – true like.

NANCY [...]

SHIV *(Beat.)* They don't feed your hysteria. That's it.

NANCY What?

SHIV That's what really bugs you.

NANCY My hysteria, you say.

SHIV Everyone's hysteria, yeah.

NANCY Over?

SHIV What do you think? *(Beat.)* Islam, man.

NANCY I'm not hysterical – I'm just interested. What's wrong with that?

SHIV Nothing. But for you, it's always got to be centre stage – the lens through which everything's understood – and judged. You can't accept it when people – Muslims especially – decide to sidestep all that.

NANCY They don't though – they wouldn't.

SHIV You see – that's what I mean. How do you know what Farouk, Laila, Aisha are thinking?

NANCY I don't, but /

SHIV / But they may not give two shits about all of this. Maybe that's why they've fucked off – to just get away from all the madness – this perpetual noise.

SCENE EIGHT

Two Muslim girls are milling about. They are clearly waiting for someone, but trying to look cool about it.

MUSLIM GIRL 1 Why do you need to speak to them? Can't we just go?

MUSLIM GIRL 2 Just five minutes.

MUSLIM GIRL 1 Fine. But I'm not saying anything.

MUSLIM GIRL 2 You don't have to.

A band enters – replete with instruments. They are cool, possibly punk, and visibly Muslims. The girls try not to fangirl too hard.

MUSLIM GIRL 1 Salam, brothers. I really enjoyed the show.

MUSLIM BAND MEMBER 1 Thank you, sisters.

MUSLIM BAND MEMBER 2 Yeah, thanks.

MUSLIM BAND MEMBER 3 Thanks.

MUSLIM BAND MEMBER 4 [...]

MUSLIM GIRL 2 I know it's probably a bit lame, but we're big fans.

MUSLIM BAND MEMBER 3 smiles.

MUSLIM BAND MEMBER 2 Thanks for coming.

MUSLIM BAND MEMBER 1 *(Beat.) (To MUSLIM GIRL 1.)* Is this the first time you've come to one of our gigs?

MUSLIM GIRL 1 Yeah.

MUSLIM GIRL 2 Yeah, we've always wanted to come, but we just never had the chance, you know.

MUSLIM BAND MEMBER 2 Ah, nice. *(To MUSLIM GIRL 1.)* I hope you enjoyed it.

MUSLIM GIRL 1 Yeah.

MUSLIM GIRL 2 Yes, Sharia Law is great live.

MUSLIM BAND MEMBER 2 The girls love that one.

MUSLIM BAND MEMBER 3 The crowd were on it tonight.

MUSLIM BAND MEMBER 2 What are you girls doing now?

MUSLIM GIRL 2 I don't know.

MUSLIM GIRL 1 You guys are really inspiring, you know. I've only recently started appreciating how many Muslim act there are – Q-Tip, The Roots, Lupe –

MUSLIM BAND MEMBER 3 Oh, yeah – Daydreamin' is such tune. That shit gets us fired up.

MUSLIM GIRL 1 Right. And how he doesn't really milk it – h religion. It influences his music, of course, but /

MUSLIM BAND MEMBER 3 / Yeah, it's kind different for us.

MUSLIM GIRL 1 *(Beat.)* No, of course. No, it wasn't a criticism or

MUSLIM BAND MEMBER 3 / Yeah, it's fine.

MUSLIM GIRL 1 The fact that you're talking about stuff –

MUSLIM BAND MEMBER 2 Yeah, it's important to put your ow experience into the music. *(Beat.)* And if it resonates – great

MUSLIM GIRL 1 I feel like you nail it. You're saying some rea interesting stuff. And I think you're helping other Muslims

MUSLIM BAND MEMBER 4 *(To MUSLIM BAND MEMBER 3)* Did you see that poster in the front row?

MUSLIM BAND MEMBER 3 I couldn't stop – I was pissing myse

MUSLIM GIRL 1 It was really great seeing kids rocking out with hijabis in the front row.

MUSLIM BAND MEMBER 2 *(To MUSLIM BAND MEMBER 4)* Fuck, she's keen.

MUSLIM BAND MEMBER 4 Yeah, me too.

MUSLIM GIRL 2 We should really get going.

MUSLIM GIRL 1 I just wanted to ask – like, my parents aren't really cool with me making music. How do you guys keep going, when, you know –

MUSLIM BAND MEMBER 2 I mean, it's worth it, right?

MUSLIM GIRL 1 Yeah, but how do you justify it, you know? Like, your lyric – "Don't tell me this is haram, this is punk, this is who I am."

MUSLIM BAND MEMBER 3 Yeah, it rhymes, innit.

The band breaks into laughter.

MUSLIM GIRL 1 But it's only haram if it leads to certain acts, right? That's how you guys justify it to people?

MUSLIM BAND MEMBER 4 Smart girl.

MUSLIM BAND MEMBER 3 Smarter than any of us.

MUSLIM GIRL 1 You've thought about it, surely.

MUSLIM BAND MEMBER 4 It's not so important for us.

MUSLIM GIRL 1 […]

MUSLIM BAND MEMBER 1 Just be free, sisters.

MUSLIM GIRL 1 […]

The conversation breaks down.

Silence.

SCENE NINE

SHIV Man, those are some cool brothers.

NANCY Really?

SHIV Totally, yeah.

The way they negotiate all the hysteria – wrong-footing everyone all the time. It's brilliant to see.

NANCY I don't know.

SHIV It's refreshing.

NANCY All that posturing though.

SHIV Yeah, but you've got to understand where that comes from. It's years of having to deal with all that fuckery.

But you're right; they don't need to give off that vibe.

NANCY *(Beat.)* Did you feel that?

SHIV What?

NANCY [...]

SHIV Nancy?

NANCY *(Beat.)* There. Again.

SHIV What the fuck?

NANCY *(Getting on her hands and knees.)* Shhh.

SHIV I must be – No, shit. Are you tripping?

NANCY *(Placing the palm of her hand on the floor.)* That. Come here.

SHIV Fuck off.

(Rummaging through his pockets.) You are. *(Beat.)* You popped it didn't you?

NANCY Can't you feel it?

SHIV No.

SHIV stops – his hand frozen in one of his pockets.

(Pause.)

SHIV takes his hand out – revealing the other half of the pill.

SHIV Shit.

NANCY *(Beat.)* Shiv.

SCENE TEN

This scene should be performed at breakneck speed, barely pausing for breath, except where indicated. There is a rapt audience watching on, almost waiting for one of them to slip up. SHIV and NANCY are really involved, to the point where they might join in.

WHITE BOY So, you want everyone wearing a burka?

MUSLIM BOY Only the women.

WHITE BOY But all women.

MUSLIM BOY No, Muslim women.

WHITE BOY But all women are Muslim women?

MUSLIM BOY In a perfect world.

WHITE BOY Imperfect world, you mean.

MUSLIM BOY No.

WHITE BOY Yes.

MUSLIM BOY No.

WHITE BOY You sure?

MUSLIM BOY I'm quite sure, yes.

WHITE BOY What's the punishment?

MUSLIM BOY What?

WHITE BOY Burka – or death?

MUSLIM BOY What?

WHITE BOY Objectification or murder?

MUSLIM BOY What?

WHITE BOY Which one?

(Silence.)

MUSLIM BOY Submission.

WHITE BOY That wasn't one of the options.

MUSLIM BOY I didn't like your options.

WHITE BOY I don't like you.

MUSLIM BOY That's neither here nor /

WHITE BOY / What about bikinis?

MUSLIM BOY What?

WHITE BOY What about a bikini?

MUSLIM BOY [...]

WHITE BOY Can you imagine my imaginary Muslim wife wearing a bikini?

MUSLIM BOY I – don't /

WHITE BOY / Bikinis, bikinis, bikinis, bikinis /

MUSLIM BOY / No.

WHITE BOY Anyone in a bikini?

MUSLIM BOY No.

WHITE BOY Me in a bikini?

MUSLIM BOY Definitely not.

WHITE BOY Hmm – I agree.

MUSLIM BOY That makes me happy.

WHITE BOY Onesies?

MUSLIM BOY I'm not aware of that term.

WHITE BOY A loose – and I quote, "A loose fitting one-piece leisure garment covering the torso and legs."

MUSLIM BOY If they're covered, yes.

WHITE BOY Ah, but they aren't fully covered.

MUSLIM BOY Then no.

WHITE BOY What do you think should be done in response to the push for global jihad?

MUSLIM BOY Well, initially you need to consider the displaced Muslims from /

WHITE BOY / Yes or no answers, please.

MUSLIM BOY I think you're trivalising /

WHITE BOY / No.

MUSLIM BOY Demonising.

WHITE BOY Not /

MUSLIM BOY / Racialising the /

WHITE BOY / Not even close.

(Long pause.)

MUSLIM BOY What would you do?

WHITE BOY Well, that's not /

MUSLIM BOY / What would you do.

WHITE BOY This is my interview. I booked /

MUSLIM BOY / Yes or no answers, please.

WHITE BOY Is Islam – let me finish – a religion of peace?

(Silence.)

MUSLIM BOY No.

WHITE BOY So, it's a religion of war, terror, destruction, fascism /

MUSLIM BOY / No.

WHITE BOY Then what?

MUSLIM BOY It's a religion of submission.

WHITE BOY Sexually?

MUSLIM BOY No. To God.

WHITE BOY Still.

MUSLIM BOY What?

WHITE BOY Sexually still to God – your God.

MUSLIM BOY How can we be peaceful towards kuffar?

WHITE BOY Iran or Syria?

MUSLIM BOY Infidels who destroy our lands.

WHITE BOY Imam or your mam?

MUSLIM BOY Murder our families.

WHITE BOY Beard or weird?

MUSLIM BOY Our law says these people must die.

WHITE BOY Fish or chips?

MUSLIM BOY And we follow our law.

WHITE BOY Sex or death?

MUSLIM BOY Adultery is penalised by /

WHITE BOY / Death or Game of Thrones?

MUSLIM BOY Box sets are haram.

WHITE BOY Worldwide Sharia get you off?

MUSLIM BOY [...]

WHITE BOY You know what gets me off?

MUSLIM BOY Go.

WHITE BOY This country – *(Applauding.)* and its motherfucking freedom.

MUSLIM BOY The political landscape has shifted, as you know the CIA /

WHITE BOY / ISIS.

MUSLIM BOY *(Beat.)* FBI.

WHITE BOY ISIS.

MUSLIM BOY MI6

WHITE BOY UAE.

MUSLIM BOY MI5.

WHITE BOY FGM.

MUSLIM BOY Your people are torturing our people. *(Beat.)* Stand in this position.

WHITE BOY Which position?

MUSLIM BOY It's a stress position. It's torture.

WHITE BOY No, it's not – it's easy, I can do this. I could top it off with a backflip.

MUSLIM BOY Hold it.

WHITE BOY Now /

MUSLIM BOY / Don't fucking talk.

(Silence.)

MUSLIM BOY Take off your shirt.

WHITE BOY No.

MUSLIM BOY Take it off.

WHITE BOY takes off his shirt.

MUSLIM BOY You're grotesque.

WHITE BOY It's clear to me that you're confused – scared even. Can I interest you in our Lord and saviour Jesus Christ?

MUSLIM BOY Let me tell you. Sharia is beautiful – the very height of what man can love, can achieve in covenant with God and the prophet Muhammad sallallahu alaihi wasallam.

WHITE BOY Muhammad sallallahu sally, pride of our alley.

MUSLIM BOY Arab culture invented time.

WHITE BOY The time? *(Beat.)* You need the time? Oh, shit. Actually, shit, we've run out of time.

MUSLIM BOY The glory of God can get to all of you. Just repeat after me – la ilaha illallah Muhammadur rasulullah.

WHITE BOY And what does that shit mean?

MUSLIM BOY With me – la ilaha illallah /

WHITE BOY / You dirty raghead.

MUSLIM BOY Repeat.

WHITE BOY I can't hear /

MUSLIM BOY / La ilaha /

WHITE BOY / Thank you. That's all we have time for tonight.

The same adult voice heard at the top of the show comes over the tannoy to tell everyone that the technical issue has been resolved, and that they can now enter the theatre. SHIV and NANCY quickly, and silently, shepherd the audience to their seats.

UNITED
IN
EFFORT

TOUR 5: NATHANIEL & CHARLIE

SCENE ONE

NATHANIEL What are you doing?

CHARLIE Nothing.

NATHANIEL Nothing? You're never doing nothing. What you doing?

CHARLIE *(Smiling.)* [...]

NATHANIEL It's always something with – you're not even a monitor. You shouldn't be here.

CHARLIE I'm just filling in for Laila – helping out.

NATHANIEL No. No, you're not. You never are. *(Looking around.)* *(Beat.)* Where's Ms. Jenkins?

CHARLIE Shut up.

NATHANIEL *(Still scouring for a teacher.)* Where the hell /

CHARLIE *(Pushing NATHANIEL in the back.)* / Just keep walking.

NATHANIEL Hey!

CHARLIE [...]

NATHANIEL Hold on. Is this another one of your –

 (Beat.) It is, isn't it? You selfish –

CHARLIE [...]

NATHANIEL What the fuck, Charlie?

CHARLIE Calm down. You're getting carried away now – I didn't do anything, alright.

NATHANIEL After that stunt you pulled during tech, you want me to /

CHARLIE / And you want me to just stand there, dance around some and smile stupid smiles. *(Beat.)* Is that it? Be part of this fucking minstrel show.

NATHANIEL How can you say something like that – something so stupid?

CHARLIE What? 'Cause they bussed in two Muslims, you think that makes it all alright?

NATHANIEL It makes it a damn lot better, yeah.

CHARLIE You're so fucking naïve, Nathaniel.

NATHANIEL Me? I'm the one who's naïve, am I?

CHARLIE Just forget it. There's no point with you. Our – what do you call it – worldviews. Yeah, they don't marry. They're in different fucking galaxies.

NATHANIEL [...]

CHARLIE *(Beat.)* You and I just see the world differently. *(Beat.)* Okay. You. You have no desire to rock the boat, right? You're too invested in it all to want to see it crumble.

NATHANIEL You sound like a –

CHARLIE What?

NATHANIEL Nothing.

CHARLIE Nothing. *(Beat.)* That's the problem with you. At the end of the day, you just think everything's fine – what with a little tweaking here and there.

NATHANIEL You're so full of shit, you are. It's all or nothing with you. And if you don't get your way, you just start throwing all your toys out the pram – like some spoilt toddler.

CHARLIE [...]

NATHANIEL *(Beat.)* So, you? What's your – radical position? Whose burden do you feel like carrying today?

CHARLIE I get it. It's because I'm white, right?

NATHANIEL *(Laughing.)* No, Charlie. It so isn't. You need to lift your head up sometimes and stop staring at your naval. If anything, it's unattractive.

CHARLIE Fucking typical.

NATHANIEL [...]

(Beat.) Look at me.

CHARLIE What?

NATHANIEL I said, look at me.

CHARLIE [...]

NATHANIEL When you look at me, what do you see?

CHARLIE [...]

NATHANIEL When you look at me, what do you see?

CHARLIE Nothing. I don't see anything.

NATHANIEL Bullshit.

CHARLIE I don't.

NATHANIEL You know – I'll give you the benefit of the doubt, yeah. But let me ask you this. *(Beat.)* What do you think the repercussions would be for me if I decided to pull one of your stunts? *(Beat.)* Huh? You think it would be same, do you? *(Beat.)* A simple slap on the wrist.

SCENE TWO

The audience enters a classroom with a grid of chairs facing the whiteboard. Facing the class, in place of a teacher, is a student. The number, gender and

race of students does not matter. They just need to be sitting in random chairs
– not every chair should be occupied. If at all possible, the audience should
sit in the empty chairs. All of the students have a scarf in hand. However, it
should not be obvious from the start what they will be doing with them. As
each action is described, the other actors replicate it. The lines in parentheses
can be divided up between actors in any fashion, but it should feel random.
Each line should be delivered to a nearby audience member, if possible.

GIRL Hey, guys. Today is super exciting because I've got three awesome hijab styles for you. Not only are they new looks, but they're hundred percent pin free. They're super quick, super simple and snazzy as hell. These three styles are great everyday looks for when you can't face jabbing yourself in the head with pins – but still want to look super stylish for the day ahead. Great. Let's get started.So, let's go over the things you need. Okay, so, for these three hijab tutorials, we need two things. First of all, you need an underscarf – or a bonnet cap. Kinda like a bald cap, but with grip, so your silky scarves don't go sashaying off your head – because that's not a strong look. You want to try and get hold of a cotton one – as it helps let your hair breathe – so it doesn't get too sweaty under there.Right. *(Beat.)* Hijabis, while we're on the topic, I'm gonna give you my top tip for healthy hijab hair. Don't tie up wet hair. I know some mornings, you're in a rush and don't have time to wait for your hair to dry – but tying up wet hair damages the roots, which is bad news. It's even worse for us hijabis because our hair doesn't get to dry naturally – and stays tied up for so long. Tying up wet hair is the number one culprit for encouraging the dreaded – hijab hair.Lecture over – let's carry on. *(Beat.)* The other thing you'll need is a long rectangular scarf. I've got this really fun maxi hijab I've folded in half. So, if yours is kinda wide, fold it in half, too – as it's just easier to control. *(Beat.)* Okay, I think we're ready to go.Our first style is a super cool turban style. Zero pins, zero stress, but all glam. So, fold your scarf in half, if you need to (ACTION 1). Pop it on the front of your head (ACTION 2). Just to make it look neater,

make sure the folded seam is at the front. This will stop your scarf flapping about everywhere. Make sure both sides are completely equal (ACTION 3) and grab hold of the corners of the fabric together, like so (ACTION 4).

[Hey.]

[Salaam, sisters.]

[Are you sure about this?]

[I mean, how old are you again?]

GIRL Try and make sure the material's tight at the top of your neck. I'm gonna get each side of the scarf and scoop it up, like that, bring them to the top of your head and crisscross them over (ACTION 5). *(Beat.)* Sweet, that's the stressful bit over. Now, at this point you can shape it round your face by just tucking in the edges and adding more folds, if that's what you're feeling. Once you've done that, you need to cross the pieces at the top of your neck again – like this (ACTION 6). Last thing, depending on how long and fancy your scarf is – just keep crossing and repeating until you can tuck the ends in wherever you can (ACTION 7). *(Beat.)* Yeah. So, all looking good. This – combined with a high neck top – makes it a hundred percent halal – and a hundred percent fabulous.

[I don't mean it in a rude way.]

[My best friend's called Amira.]

[We share the same bus route.]

[How did it begin?]

[What's the weather like?]

[I'm sorry for my shitty pen.]

GIRL Awesome. Well, next up, we've got a kinda wrap around bun style. For this to work, it's best to have your hair in a low bun – under your bonnet cap. If you can't, stick with me, it should still work. First step, fold your hijab in half, if it's big

(ACTION 8) and put it on the top of your head, with the seam on your hairline (ACTION 9). *(Beat.)* Beautiful. Make sure the fabric is even on both sides (ACTION 10). Next grab both sides – flick them over your shoulders. This is where your inner sass can come out *(*ACTION 11*)*. Try your best to keep the tops of your ears underneath the material – otherwise, you can end up looking like a kinda Muslim elf *(*ACTION 12*)*. How can you turn your hijab into a costume is a whole other tutorial. Grab one half of the material in each hand and cross them underneath your bun, or at the base of your head, if you haven't got one. This should help keep everything secure. Then wrap the pieces 'round the bun and cross them at the top. Keep crossing and wrapping until you can tuck the ends in or tie them together (ACTION 13). I think this style is very sophisticated. And I would pair this with a, like, cool maxi dress and statement necklace for a really smart and on-trend look.

[Hello, I don't know much about you.]

[I saw your dad on TV.]

[I don't know what you are.]

[Apparently you like Keeping Up with the Kardashians – I can't say that I do.]

[People will either label you as traitors or children.]

[You have become those three girls.]

[I've seen you on Twitter.]

[It's actually getting quite serious now.]

[Trillions of stars follow your steps.]

[I certainly would never be brave enough to run away at sixteen.]

[I heard you got sold.]

GIRL Our final style in this tutorial is the more traditional hijab, but most importantly – pin free. It takes like thirty second – when you've got it down – and it's great for those days when you're in a rush, but still want to look fine. Just like our other two styles, fold the hijab in half, if that's what you need to do (ACTION 14) and pop it on your head, seam on your hairline (ACTION 15).

[I can't imagine deciding to sod off to Syria.]

GIRL Okay, guys. Key here is to make one side longer than the other. Like there's not much in it, just a couple of centimetres – it makes all the difference between a horrendous hijab and a hella fleeky one (ACTION 16).

[Honestly, I hope you're ignorant.]

GIRL Now, pinch both sides tight under your chin (ACTION 17).

[Cookies n cream in Bethnal Green.]

GIRL Pull the short side tight – downwards, like so.

[It's not funny anymore.]

GIRL Whilst keeping the short piece held down, shimmy the long one over the opposite shoulder – using the ultimate sass.

[I wish you all the luck in the world.]

GIRL Then wrap the longer piece loosely 'round your neck (ACTION 18).

[A cynical, ideological terrorist group.]

GIRL Tuck the end of the piece into itself, like so. This covers your neck, perfectly (ACTION 19).

[You're not a bad person.]

GIRL At this point you have a stylistic choice. You can either leave the short side down. This is good for extra chest coverage, if you're looking for more modesty (ACTION 20).

[I don't agree with your decisions.]

GIRL Or wrap it 'round as well, whatever you fancy. You're in control of your hijab's destiny *(*ACTION 21*)*.

[Come home, please. If that's still an option.]

GIRL Then just tuck it in. This should keep it in place. With both ends tucked in, this style is good for when you're being active or sporty, as you haven't got a hijab flying everywhere. Or in winter, it doubles up as a sorta snood thing (ACTION 22).

[You were looking for something to believe in.]

GIRL Finally, just give it a tuck and roll 'round your face to shape it up, making sure you're happy with how it's framing your beautiful face (ACTION 23).

[Just think about the connection between us all.]

[I hope you're happy with your decision. *(Beat.)* Maybe that's the only thing that fucking matters.]

[You've been on TV and everything.]

[Why?]

[Your words, only.]

[I don't know anything about Islamic wedding ceremonies – and if jihadi ones differ.]

[What made you believe you were doing the right thing?]

[No-one truly deserves to die in such a horrible way.]

[Check the time, sweet sisters. Check the time.]

[From a nobody.]

[P.S. I don't agree with you.]

SCENE THREE

(Pause.)

CHARLIE […]

NATHANIEL […]

CHARLIE So?

NATHANIEL Don't –

CHARLIE What?

NATHANIEL Just – please.

CHARLIE I didn't say /

NATHANIEL / You've always got something to say. *(Beat.)* I don't want to hear it.

CHARLIE No /

NATHANIEL / Oh, my /

CHARLIE / Of course you don't.

NATHANIEL You just can't help yourself, can you?

CHARLIE You're telling me you had no problems with it whatsoever?

NATHANIEL No – I didn't.

CHARLIE You can't see how patronising /

NATHANIEL / No.

CHARLIE How totally fucking insincere –

NATHANIEL Nope.

CHARLIE Removed of any kind of politics –

NATHANIEL Nuh. Frankly, it was the safest, tamest – most inoffensive – *(Beat.)* it's Ms. Jenkins for Christ's sake.

CHARLIE Yeah, and that's the problem.

NATHANIEL No, the problem's that you somehow manage to get riled up about everything under the fucking sun. Shit, it must be tiring.

CHARLIE Well – the world's shit.

NATHANIEL *(Laughing.)* Is it?

CHARLIE And these – liberal do-gooders, like Ms. Jenkins, do more harm than good. What's worse still is I can't say anything because it's all been legitimised by bringing in them two to – to add some authenticity. It couldn't be more transparent – or disingenuous. But everyone's in on it, right? It's like some grand pact – a secret handshake.

NATHANIEL *(Still giggling along.)* Jeez – you're on a roll today, girl.

CHARLIE [...]

NATHANIEL We get the world we deserve. And you know what – at times, it's super beautiful. *(Beat.)* It ain't all run by the Illuminati. It's a shame you can't –

CHARLIE [...]

NATHANIEL *(Beat.)* And Ms. Jenkins is safe.

CHARLIE She'll turn into a right-wing bitch with age, for sure – watch.

NATHANIEL Oh, Lord.

CHARLIE They all do.

NATHANIEL The only one who's going to end up a reactionary – *(Beat.)* is you.

CHARLIE Oh, yeah? How you figure that?

NATHANIEL 'Cause you're just like my dad. He was full of all this – conviction, everything – I mean, everything mattered, you know. But that left little room for any compassion – for space to see people in their entirety – to enjoy watching them

change and grow, ultimately. I don't want to end up like that – like him – bitter, ill and – alone.

CHARLIE [...]

NATHANIEL He lived in that hot seat this society created for folks like us – constantly – every day, you understand.

CHARLIE Yeah.

NATHANIEL I don't think you do. He died a broken man – having spent every breathing moment of his life here scrutinised – every misplaced step judged. And that's what my generation don't get – that everything – every fucking whisper, or thought, even – has repercussions – and not just for us. *(Beat.)* I love Farouk, but look – look at all the madness he – all of them have brought on – and for what? For some moment of – whatever /

CHARLIE / Let them rebel.

NATHANIEL The cost ain't the same. A whole community ain't going to have to pay for your – fuck up.

SCENE FOUR

This scene can be played by as many actors available, but the football teams should have a minimum of four players each. Gender and ethnicity do not matter, but A must be clearly marked – wearing a Spurs strip on top of his clothes. He is also Jewish.

A scores – an eruption of cheers from his teammates and groans from the opponents.

A How do you like that boys?

(Kissing the badge on his shirt.) Tottenham Hotspurs – read it and weep.

B *(Jokingly.)* Oh, fuck off, you Yid.

C Oh, you're just jealous, mate.

D Jealous of what? Having a Yid on your team?

C Stop being such a bitch.

D Just being honest.

A *(Joyously.)* Damn right, mate. YID ARMY all the way.

B Oh, fuck off.

A Just because we're top of the league. *(Beat.)* Where you? Fourth? You're going down, mate.

E Yo, you guys – chill out, chill out. *(Putting his hand out – then giving them the middle finger.)* Shalom, brother, shalom.

A Fuck off – go back to your mosque and pray on the doormat.

E Oi, someone take Pinocchio off the pitch – his nose is getting in the way.

F Shit joke –

ENSEMBLE Shut up, Sam.

E Joseph and his technicolour kippah.

A Oh, fuck off – go and blow up a bank, or something.

G Isn't your dad a banker?

A Erm, yeah?

C Isn't your dad a banker, too?

G Yeah, but my dad actually worked hard for where he is. It wasn't just handed to him.

B You people should work hard just like the rest of us. Instead, you live the easy life – punishing Palestinians for kicks.

A How can you back him up right now? Don't you see what he's doing – being prejudiced just like what happened to your /

B / Don't try and turn this on me. *(Coming between the two of them with the ball.)* We've had our time – and you know he's got a point.

H Guys, guys – come on. All that matters here is that it's three-all. Let's finish this.

Others in the group respond with cheers of – "Yeah", "Come on", "Let's kick their ass". The game resumes.

G *(Muttering – but still audible.)* I'm not playing with a dirty Jew.

Others in the group respond with – "Wow", "Chill out", "There's no need for that", "Leave it" – as well as with awkward silences.

A No, whatever – let him have his say. But say it to my face, if you're going to say it at all.

(Pause.)

G *(Beat.)* You people are cancer. You just can't admit it, can you? For thousands of years you've spread greed and corruption across the world like a disease. It's not just me. *(To a Muslim in the group.)* Does it not say in the Qur'an that Yids are the ones "most hostile to believers", your people. It's fucking AIDS.

Someone in the group calls G a "Nazi".

G Don't call me a Nazi. I'm no fucking Nazi. But it was them who started that war – it was people like him. The Jews were boycotting German goods – crippling Europe. Yeah, crimes were done against them, of course – but they had it coming to them. Those crimes don't even compare to what these Yids have done – just look at Palestine. This country had the right idea once upon a time – kicking the fucking lot of 'em out. *(Beat.)* And in Russia, where the Tsar welcomed them in, then what – they tried to assassinate him. It's fucking greed – corruption and greed. They're blocking borders, starving an entire nation because they want more and more land. Have you lot not seen the news? Or read a fucking book? They've been evil from the start of time. And now they're bombing fucking children on beaches in Palestine. How long will it be before he's trying to

do the same to this country. They've got the same filthy, greedy hearts.

As G continues spewing bigoted ideas, everyone else starts to move to one side – alienating G.

A So – does everyone feel the same way?

There is a unanimous response from the group of – "No", "No, it's not you, man", "Of course not, no", "Don't listen to that fool".

A leaves.

The rest of the group mill about, clumsily.

G *(As people start drifting off for a variety of reasons.)* Are we going to play, or what?

(Pause.)

SCENE FIVE

(Pause.)

CHARLIE Earlier.

NATHANIEL […]

CHARLIE Before.

NATHANIEL Yeah.

CHARLIE *(Beat.)* Sorry.

NATHANIEL […]

CHARLIE I didn't know –

NATHANIEL Yeah.

CHARLIE You know?

NATHANIEL Sure.

CHARLIE If I had, I wouldn't have –

NATHANIEL It's okay.

CHARLIE *(Beat.)* So, we cool then?

NATHANIEL We good, yeah.

CHARLIE [...]

NATHANIEL *(Beat.)* You're still annoying as hell. A persistent pain.

CHARLIE Touché.

(Pause.)

CHARLIE *(Beat.)* You know what you said before?

NATHANIEL What?

CHARLIE You know – about me ending up –

NATHANIEL *(Beat.)* A reactionary bitch.

CHARLIE Yeah, that.

NATHANIEL Yeah.

CHARLIE You don't really believe that I will, do you?

NATHANIEL [...]

The beep, beep of a mobile phone.

NATHANIEL takes out his phone.

NATHANIEL *(Staring into the screen.)* [...]

CHARLIE Nathaniel?

SCENE SIX

It is important that all the actors who speak in this scene are white, but gender does not matter. At first glance, it must appear that they are all sat normally – maybe all at the same table, or scattered around, but they are having a fierce debate. It is only after a few moments that the audience may realise that there are people of colour in the room – maybe relegated to the corners,

hiding under the furniture – maybe even as the furniture. Whichever
option, they must not be at ease. Their positions are clearly uncomfortable,
painful, but they are also stoic. Throughout the scene, the people of colour
remain silent – and without gesture.

A That's what we've been trying – or I've been trying to say. But
you all called me a racist. Everyone likes freedom of speech,
and equality and shit, but when I said that it's lacking in Islam,
everyone got upset.

B So true! We're fine with criticising Christianity, like the "God
hates fags" thing with Westboro Baptist, and all that. But
when you want to chat about misogyny and homophobia,
blah, blah, in Islam, everyone clams up.

A Thank you! Finally, someone who gets it!

B All of a sudden, it's like you can't criticise Islam without being
Islamophobic.

A Yes!

B It's mad.

C Uh, did you write the Qur'an?

B Mate, I know what I'm talking about.

C Whatever. You're saying Islamophobia isn't a real thing?

A Well, it's not when we do it.

C Fucking hell.

A It's not, though.

D Islamophobia exists, but /

A *(To C.)* / Why you getting so wound up?

C I mean, it's gross, it's racist /

D / We have to be able to call out fuck ups.

C Of course we do, but /

D / But Islam at the moment is the mother-load of fuck ups.

C Jesus.

A It's just a fact.

C No, it's not. It's not – a fact. It's an ugly thing to say.

E There's only certain things liberals can tolerate.

D Guys. Can I just say /

E / You're forgetting about all the good Muslims. Of course, you've got your terrorists, your jihadis and Sharia law dickheads. But you're forgetting the Malalas, the Muhammad Alis. Like, I know Muslims. We know real Muslims.

C Yeah, what about the normal everyday kind of Muslims – go to school, go to work kind of Muslims. Play CoD, go to mosque kind of Muslims.

A Hold up, hold up! You're saying no Muslims are extremists?

C [...]

A Uh, Saddam? Jihadi John? *(Beat.)* Uh, the shoe guy?

D Gang, can I just say – we have, like /

C / Okay, yeah – there are some – whatever, but it's not the majority.

D Listen. There's, like, over a billion Muslims, right?

C It's more. There's more than that. It's more like a quarter of /

D / Will you just let me speak!

(Pause.)

C Fine.

D *(Gesturing.)* So, first you have jihadis who wanna kill infidels and die trying.

C Yeah, terrorists.

D *(Gesturing.)* Then second – we have Sharia law people, who actually have the same ideas, but just aren't willing to blow themselves up on a bus, or tube, or whatever. *(Gesturing.)* These two make up probably – twenty percent /

C / Bullshit!

D But then you've got the fundamentalists, who agree ISIS are fucked up – and are against terrorism, but still have this homophobic and misogynistic agenda. *(Beat.)* Just think about it – women, in burqas, can't drive. They don't allow gays. These are your normal, everyday Muslims, who are just following the Qur'an.

E Every religion has extremists – it's not just Muslim fundamentalists. There are Christians – who was that dude? That Christian dude who shot up that black church?

D But we're saying even the moderates hold extreme views.

F You're saying there are more extremists than we give credit for – that they aren't a minority.

D Exactly.

F No, listen. You're saying that, but actually we don't hear them because we don't listen to them – the millions of moderate voices that are against ISIS.

A That's because they're too scared to speak out. It's the only religion that acts like the mafia – like they'll fucking kill you if you say the wrong thing. There's a reason Malala got shot in the fucking head.

F But she spoke out – other people have spoken out. Why don't we listen to them as much as the terrorists.

A What they're doing is wrong. They line people up and shoot them.

C Mate. Glass houses.

F [...]

C Iraq?

A That's irrelevant.

C Mate, listen /

F / We have. And we're telling you – it's irrelevant.

C You know – "black people, you know, they just shoot each other."

A What?

C It's like saying Jimmy Savile was charged with paedophilia – so we now know that Ant and Dec are spit roasting eight year olds!

D Fine, fine – there's a majority of part-time Muslims – and we should encourage them to revamp their faith.

C ISIS couldn't fill Hyde Park, and that's all you fucking talk about. ISIS, ISIS, ISIS – change your fucking tune!

D It's bigger than – Hyde Park.

A It's not about ISIS. It's about full-time Muslims making a global push for Sharia law.

C You're talking about people – real people. And it's gross.

D No, it's not the people – it's their ideas.

A And the people who believe in them – push them on others. You can't separate the two.

E You sure you wanna go there? *(Beat.)* It's the same as the black people racism bullshit.

A So, because they're a minority, we can't take the piss out of Muslims?

D Criticise Muslims.

C They aren't a minority. It's the second biggest religion in the world.

A Yeah, but you're treating them like a minority. I mean, if Filipinos were capturing teenagers and trafficking them, we would call it out. We wouldn't just let it go because they're Filipinos.

C We would criticise the ones doing it – not the whole fucking country.

A No, no, mate – we were talking about ISIS.

C Fuck's sake.

A Let's talk about that.

SCENE SEVEN

CHARLIE […]

(Pause.)

CHARLIE Was it him?

NATHANIEL Who?

CHARLIE Before we –

NATHANIEL […]

CHARLIE The text.

NATHANIEL […]

CHARLIE […]

NATHANIEL *(Beat.)* I don't get it.

CHARLIE What?

NATHANIEL Why they've gone backwards?

CHARLIE Backwards?

NATHANIEL To show that – after – it doesn't make any sense.

CHARLIE He/She was awesome.

NATHANIEL [...] You didn't notice anything wrong with it – nothing at all?

CHARLIE No. He/She didn't back down – and had the final word.

NATHANIEL You didn't find it odd, uncomfortable even? All these people shooting off about Islam and there wasn't even one Muslim voice there.

CHARLIE No, why does it matter? He/She was defending – standing up for them.

NATHANIEL You understand that's not the same thing, right?

CHARLIE If it's all positive, what's being said – then no, not really. I couldn't care less.

NATHANIEL But if they exist – if they're out there, why not – I mean, we just saw them.

CHARLIE I know.

NATHANIEL Well then – how about we let them speak for themselves, huh?

CHARLIE [...]

NATHANIEL You called it a minstrel show, not me.

CHARLIE That wasn't – black artists blacked up too, you know.

NATHANIEL *(Gobsmacked.)* [...]

CHARLIE *(Beat.)* I'm just saying – trying to say, quite badly, I know, that – at the end of the day, it's what they say that matters. *(Beat.)* Right?

NATHANIEL *(Beat.)* When I asked you what you saw when you looked at me, what did you say?

CHARLIE *(Beat.)* Nothing. But I didn't mean /

NATHANIEL / Nothing.

CHARLIE [...]

NATHANIEL You were right.

CHARLIE Nathaniel –

NATHANIEL We're always in the spotlight – under the microscope. Everyone just waiting for us to slip up – fuck things up. But when it matters – when it truly matters, we become totally invisible – silenced.

CHARLIE [...]

NATHANIEL And just look at Farouk and the others now. It's the same fucking thing.

SCENE EIGHT

The black girl performing this scene is completely free. She does not care what the audience (or anyone else) thinks. She is totally comfortable with them – assuming they are on her side. She has never apologised for anything, and does not intend to start now.

BLACK GIRL So, I'm halfway to Paris, right – I'm like three hours in. It's two in the morning. We're already delayed as the coach keeps on stopping because our driver, ironically a Muslim, keeps disappearing behind the back of the bus. So, we're already off to a great start. We get to another one of these mysterious stops. The driver gets off again – and this woman in a hijab gets on with four loud young boys. Wallahi this, wallahi that – I know, which then proceeds to wake up the baby of the other Muslim family behind me, who have been munching on some vomit smell snack the whole fucking way – leaving me with a constant drone of Arabic. Exactly what I need for a six-hour coach journey – a crying baby, weird smells and being pushed up against every time one of them goes to the toilet. I forgot to mention – by our third stop, I had acquired a male Muslim friend who took the empty seat next to me – shoulder barging me every time he furiously turned

159

the page on his dodgy Arabic transcript. I hate to say it, man – but by this point, I'm a little on edge, a lotta on fucking edge, actually. The guy's going down the aisle, asking for passports and tickets, and you won't believe it – you really won't fucking believe this. Guess who this guy decides he wants to search? *(Beat.)* Me. He leans – he leans over my man to ask me to step off the bus. I have to shimmy my black ass past this fucking possible mujahedin – am ushered off this ticking time bomb, past all these wandering eyes, beards and spices. They were looking at me, at me, like I was the fucking outsider. I'm outside this bus at three AM with a bunch of Muslims, the real threat, looking down at me. I flip 'em off – I'm that fucking angry. I know, I know. Out of the tent letterbox bitch, who could have been a fucking alien for all I know, Mr. and Mrs. Osama and their brood of baby Boko Harams; and the driver, who constantly had to go to the jihadi john on that crazy Taliban tour bus – they choose me to search. I mean, we're on our way to Paris, with a coach full of Muslims, and they search me. And I'm not talking about, you know, fucking colour, or any of that. I'm talking about the fact that I'm British – born and raised in the fucking capital of my country, but for fuck's sake, postbox bitch could've been from any fucking where, none of these fuckers were speaking English. I can promise you they were wallahi'ing the whole fucking way. I mean, instead of booking a ticket to Paris, did I book a ticket to paradise? The guy's holding my British passport in his hand – and I'm stood outside this bus, me, probably the only British son of bitch there, and proud to be, with all these fucking foreigners looking down at me – Jesus, it's absurd, it hurts. He chose the black girl – fucking racist.

SCENE NINE

CHARLIE Happy?

NATHANIEL [...]

CHARLIE Got what you wanted, no?

NATHANIEL [...]

CHARLIE Your treasured authentic voice.

NATHANIEL We get it, alright.

CHARLIE What? And let that jingoistic prick off the hook?

NATHANIEL Okay. Calm down.

CHARLIE No way.

NATHANIEL Stop, yeah.

CHARLIE She's a fucking racist.

NATHANIEL Racist. *(Beat.)* Yeah. You always have to – *(Beat.)* She's prejudiced, yeah, maybe, but /

CHARLIE / It's racism, Nathaniel.

NATHANIEL Listen, yeah. I'm not going to defend – *(Beat.)* Reverse racism – or whatever you're calling it these days – it isn't a thing, yeah. It's a myth.

CHARLIE Wow.

NATHANIEL Jesus, Charlie. For black people to be racist – we would have to – feel the need to conquer, colonise, dominate and enslave – to go on a quest to proclaim our superiority. *(Beat.)* Do you see that happening anywhere in the world today? 'Cause I sure as hell don't.

CHARLIE How can you /

NATHANIEL / You're not going to drag me into –

CHARLIE Into what?

NATHANIEL [...]

CHARLIE What?

Come on, mate.

NATHANIEL suddenly looks worn out.

NATHANIEL Stop.

CHARLIE No, I wanna hear it.

NATHANIEL Stop, yeah.

CHARLIE [...]

NATHANIEL Stop, I said.

CHARLIE [...]

NATHANIEL Stop. Okay.

CHARLIE I didn't say –

NATHANIEL Stop – please.

CHARLIE Nathaniel.

NATHANIEL [...]

NATHANIEL is close to tears.

SCENE TEN

The audience enters – 'BAN THE HIJAB' is spray-painted on the wall. They are given a moment to take it all in. Two Muslim girls suddenly burst in. They are in the middle of a very heated argument – failing even to register the audience. MUSLIM GIRL 2 wears a hijab.

MUSLIM GIRL 1 I get that – and that's why I feel the Middle East and North Africa needs legislation, education and a more prominent female voice to encourage male cooperation and enlightenment of the female struggle.

MUSLIM GIRL 2 And it's the female struggle that you focus on.

MUSLIM GIRL 1 Well, how could I not, with 91% of girls in Egypt, my country of birth, brutally mutilated. Or the 12-year-

old girls who die giving birth in Yemen. Or Morocco, where sixteen-year-olds are forced to marry their rapists, so they can avoid conviction. It's a serious problem.

MUSLIM GIRL 2 These are all fair points. But your vision is somewhat naïve. What these girls need is something more focused. We need to understand where this hatred stems from.

MUSLIM GIRL 1 For me the answer's simple – hatred towards women is embedded in the Arab world.

MUSLIM GIRL 2 But you're being totally reductive – homogenising the whole of the Arabic-speaking world.

MUSLIM GIRL 1 begins to protest.

MUSLIM GIRL 2 / If there is one thing that unites these countries, it's political oppression, the lack of democracy. More than that, you're claiming the voice of all Arab women.

MUSLIM GIRL 1 Feminism isn't about celebrating something that then comes in and cuts feminism off at the knees. The niqab, for example. It acts as an eraser of Muslim women – in one swoop. And in response, in one fell swoop, we should ban it.

MUSLIM GIRL 2 Again, you're willfully ignoring the independent agency of women by imposing your own view on them – the way they should act in the public sphere, regardless of whether or not they themselves choose such dress. It's the approach of a fundamentalist.

MUSLIM GIRL 1 No, I'm putting myself in a very difficult – a very vulnerable position. I care about women. I want to make a difference.

MUSLIM GIRL 2 By employing despotic tactics?

MUSLIM GIRL 1 No different to the way men have acted –

MUSLIM GIRL 2 That's not what we're discussing.

MUSLIM GIRL 1 That's exactly what we're discussing – for the greater good of all.

MUSLIM GIRL 2 And can such illiberal ideas ever pose as the building blocks for the greater good, as you put it?

MUSLIM GIRL 1 When there's consistent violence towards women – the sexualisation, the cutting, the abduction, the enslavement – then yes.

The same adult voice heard at the top of the show comes over the tannoy to tell everyone that the technical issue has been resolved, and that they can now enter the theatre. NATHANIEL and CHARLIE quickly, and silently, shepherd the audience to their seats.

THE SHOW

This section should be performed by the maximum number of actors available. An actor can play more than one part in different sections (except for the interviewers, who must remain constant throughout). Actors, however, must completely change their appearance when they switch between characters in different sections. The costumes should be in plain sight of the audience, so that they are aware of the mechanics of transitions and character transformations. If not speaking or transforming, actors mill about on stage – eating, drinking tea and listening to whoever is speaking. All the characters are not Muslims – until the final section.

The audience is filed into the main auditorium, which is set up in a conventional theatre layout. The setting is a town hall meeting – stacks of chairs and tables covered with cups of tea and biscuits.

Once the audience is in place, the lights go down.

1.

A voice comes over the tannoy.

INTERVIEWER(S) VOICEOVER *And what's your kind of experience of Bethnal Green? What was your – what did you think it was going to be like before you got here?*

Two interviewers – one of whom is played by LISA – enter the stage.

SOCIAL WORKER So, I didn't have any preconceived idea apart from when I did arrive here – my colleague explained, err, the community is predominately Bangladeshi, and it's the largest Bangladeshi community outside of Bangladesh. So, that was, that was, erm, an eye-opener for me, as well because I didn't have that much information.

STRIPPER 1 Yeah, it's quite, it's quite something – and I tell ya, actually, now I come to think of it, really, there's a hostel on our

street as well. There's a hostel that, erm, you know, provides temporary accommodation for people who are in other words, homeless, right? So, every night, there is more left, some kind of, err, tirade of abuse being shouted at someone. There's like, that community bring with them a kind of, a completely different set of, erm, dynamics to, like, you know, the daytime – dogs, children, bikes, beards, prams. And at nighttime, it's like, properly down and out – like junkies and drunks, and people who are the kind of, you know, living on the fucking edge, you know, that, properly marginalised, and we, you know, we're sort of occupying the same space, and I feel, I guess because I live in a flat with single glazed windows and my bedroom is like, right on the street – so it's almost as if it's kind of going on in my fucking room. But it, you know, I've noticed, I have noticed, certainly with the election and the new government, that the number of fights breaking out lately has escalated. Like, no doubt, I got woke up at seven in the morning the other day by two women screaming at each other – at seven in the morning. And you know, they sound like local people, they sound like poor Londoners.

WIFE 1 Why do you think we've got a big dog? We can't handle it.

HUSBAND 1 It's got worse.

WIFE 1 He's late '50s. I'm '50s as well. We have to have a big dog – have to. It's just not safe.

HUSBAND 1 I think I feel safe here – a lot safer.

WIFE 1 But you know what does me? When you get a lot of them, not being rude when I say this, but yuppies – they come here, a lotta of young people – they come here, and they walk these streets.

HUSBAND 1 Yeah. They don't know /

WIFE 1 / And they don't know. And I try to say to them, don't walk the streets after eight o'clock on your own in the winter –

cos you'll end up either getting mugged, beaten up. You can't do that.

FLOWER MARKET SELLER I know it's here [the Muslim community] but we don't really see it. Okay, in the mornings, you see like a few of the youngers around here – who I've dealt with over the years, you know. You see them as little kids, and they're climbing on and off your lorry – and later on in life, they're coming up, "alright mate", you know. They're actually your friends – wanna be your friends later on in life. But you don't really notice them around here, you know. It's hard to believe that there is that many in this area. I know Brick Lane is like – a very Muslim area, but you don't notice it – and it doesn't affect anything.

SOCIAL WORKER I've recalled their photos on the news, the age group being quite young. Erm, err, impressionable – and immediately I think of the young people that I support, erm, and the influences that they are put under by people within the wider community to, erm, to help the influences that I suppose are negative that are out there, that help to promote negative concepts in order for people to give up their structured life to go abroad to something that they have no idea or concept about what they're really going into, erm, under somebody else's ideology.

REVEREND Yeah, certainly, erm, erm, there were different strands to that, erm, err, I mean, there have been a number of events over the last year. First of all, erm, we, we had something of the Trojan Horse thing here. Erm, and then after that, that didn't really go anywhere, erm, after that, err, one of our local church schools, erm, secondary church schools, erm, failed an Ofsted. It had previously been really high achieving, erm, on the basis that they had allowed their students to access websites at school that, erm, err, led to extremist contacts on the web.

FLOWER MARKET SELLER Everyone for themselves. But I think if they're living in the country, they should abide by our rules, and they should live our way – and none of them want to seem to do that. So, I always think to myself, 'Why are they here?' That's my feeling, you know. Why are they here? If they wanna go off and fight in another country, what are they doing in the country to start with?

REVEREND That, yeah, that gets written off as well – as either they don't care – they're just interested in, ah – it's interesting, interesting, they're interested in, err, in drugs and violence in the part, but they're also extreme Muslims. So, hello! I don't think they quite fit together. Erm, so there is – there's that sense and, err, for me, erm, young people who should be questioning the world that they're in, they should be questioning that status quo. Erm, as a young man, I saw Christianity as a radical source of, erm, of another view of the world that I was living in – and I was seen as a bit of a pain. I wasn't seen as an extremist or terrorist because I – I was making that sort of judgment.

SOCIAL WORKER I heard that they were returning. So, I don't know. I haven't looked into –

REVEREND Erm. So, though there was those other things, erm, th – that had been in the air before, but on a wider basis there was, erm, there first of all, that there's – ahm – an ongoing, erm, magnifying glass held over Tower Hamlets, erm, claiming that it is, erm, it is Britain's first Islamic Republic. Erm, and particularly at the time when groups like the English Defence League or Britain First ha – have tried to show up here. And there is therefore, the – there is, err, a sense of, erm, a fear, erm, a sense of injustice here – never mind about the connections with other places in the world, but, erm, but of th – that population feeling that they are under the spotlight, that the finger's being pointed at them, that all sorts of untruths are being said about them, erm, and on top of that, that there is

a concern a – amongst many young people about the state of the world, that, um, you know, that's how things should be. I'd hope the young people are concerned.

2.

BUSKER I don't really remember the pictures. I don't know anything, really. I suppose, well, erm, well, my cricket team was having cricket nets in for – in the academy there. And it got cancelled one week because of these girls – and that's the worst thing about the war on terrorism – that our cricket nets got cancelled. And it was really sad because we're a rubbish team, and we need to practice.

BOY Naw.

BUSKER But it was on a Sunday. I don't know why they even – though, I mean these girls didn't go to school on a Sunday.

YOUT 1 D'all went to my school. I would probably say they went to probably try get away from this economy, get away from our government, fight for their freedom, I guess? Like, everybody thinks they're free, but really truthfully, you're not. Everybody's in the system one way or another, innit? Like from the time you're born your birth certificate is in the system. So, you're in the system – if you don't send off for it, you're gonna pay stupid fines. Like, why am I giving the government money just to show identity of who I am? I dunno, anybody else got anything to say?

GIRL 2 Kill someone?

GIRL 1 I dunno, you know.

GIRL 2 [...]

GIRL 1 I feel like they're gonna kill someone or something.

GIRL 2 Like –

GIRL 1 If you join a terrorist gang.

GIRL 2 Do something for other people that are scared to do something – something that isn't legal.

GIRL 1 If they go Syria and come back –

GIRL 2 Yeah, yeah, yeah, yeah –

GIRL 1 They should be arrested because everybody knows in London that Syria is – it's a bad situation right now.

BOY Yeah, if you, if you decide to go and fight like, of, for them kind of people, like in, naw, don't come back, cuz that's serious, man, th – them, like I've heard so many stories about these people and what they do. I've seen videos of, it's too crazy, and I don't think, if you're gonna join them, then stay with them, and just keep it like that, cuz we don't want people in this country. We don't want them kind of people in this country, like, erm, yeah, and even if you're supporting them, same thing. We, man, that's how I feel.

BUSKER Mmm.

BOY Erm, but maybe like, I – I dunno –

GIRL 2 But we don't really know who's good in there and who's bad. So, we should, like, talk to them, and, like see who they are and stuff.

BUSKER I think have 'em back – keep an eye on 'em.

YOUT 1 They get some harsh training. Don't get me wrong, I don't believe in this terrorist – at the same time, like I don't think you should be calling God's name in war, whether you're a Muslim or a Christian or a Jew – wh – whatever religion you're coming from, innit? If they come back. Yeah, I'm not gonna say they gonna – peop – their peoples gonna be here open arms for them. They're gonna be looked at as – what do ya call them, over there in America –

YOUT 2 Disciples.

YOUT 1 Disciples, you know, you madman, over here, nah, man. When they're on the run an' that –

YOUT 2 Trust me, they're disciples.

YOUT 1 Nah, man. They'll be criminals, mate. Obviously – come on. They left the UK to go and fight for peoples who's fighting against the UK /

YOUT 2 / What happens when they come back to the UK though?

YOUT 1 That's how it's gonna be – they shouldn't /

YOUT 2 / There's gonna be a protest soon as well – soon in August.

YOUT 1 Uh – huh.

YOUT 2 They gonna go protest about a thing in France.

YOUT 1 Err.

YOUT 2 About religion.

FEMALE INTERVIEWER Do you think it's wrong that people go and join groups /

YOUT 2 / Nah, not really. Basically, they're fighting for their own pride, their own freedom, or their culture.

YOUT 1 Wrong.

YOUT 2 It's not wrong.

YOUT 3 You don't think that's /

YOUT 1 / I wouldn't say it's wrong what they're actually doing there, just being indoctrinated, like how some of us are really – they're entitled to their opinion. What I would say is wrong is the people who are in essence, indoctrinating them.

YOUT 3 True.

YOUT 1 Like, like the hierarchy should be so to speak – yeah, them kind of people –

BUSKER Personally, I'm not scared of Muslims or anything like this – or judgmental, to be honest. But I think, you know, London's an isolating place as – enough as it is, you know, sort of trying to be friends with the Muslim community as well – just any friends, any friends.

YOUT 1 I'm not intimidated or anything, but obviously the people aren't gonna start blowing stuff up, like ever – that's the think as well, like, Muslim people are being shunned. I'm not Muslim myself. They're being shunned because of one group. It's like me sayin', "I'm a black guy with a gun, you should fear every black man because he could potentially have a gun," like just boom – stereotyping everybody, that's like, that's not right, that's what, err, the media's doing.

MALE INTERVIEWER And do you think that the treatment of Muslims has changed post-9/11, post-7/7, with everything that's happening in Iraq and Afghanistan – do you think the way that people treat Muslims in the community has changed?

YOUT 1 Yeah, definitely. People – some people are probably intimidated by Muslims because the fear the media is spreading from the 9/11 bombings, like, I could, literally a hundred percent put hand on heart that Muslim people weren't responsible for the 9/11 or 7/7 bombings. I wouldn't even say it was Muslim people. I would just say it was – the government, they've covered it up – found somebody to be their little scapegoat. That's it, really and truthfully. They're making the Muslim people look like, not – not the stronger race as such. They're making them look like they're bad, like, all, every single Muslim is a terrorist, and that's not the case, like.

YOUT 4 Propaganda, innit – it's propaganda.

YOUT 1 Yeah, yeah. That's the right word for it.

YOUT 4 Propaganda and the media. But, if you really go and communicate and interact with a Muslim person, you won't

find nuthin' but peace – and peace is something that you can't buy – respect.

STRIPPER 2 And, I dunno, people are just desperate for answers now and they're kind of looking at fairly, fairly extreme solutions, but these are kids, you know, like, I can – I can understand that if you're, like, a young Muslim girl, 14 years old, you've been brought up to, like, wear, you know, to cover your body and that, you know, shame – ashamed – to be, like, yeah, to have shame – bodily shame and sexual shame. And then to kind of be surrounded by Western women with all there, you know, bits and pieces out, and, you know, showing it all off and then, you know, to have that kind of conflict going on must be a fucking nightmare. And they must look at – I guess they must look at, like, local – maybe they look at local women and think, "I don't wanna be like that, I wanna go as far – I want to be as far away from that as possible." And so the attraction of being, you know, a Jihadi wife is – it must be very seductive – that must be a really big draw.

GIRL 2 Well, there are two different – one people have, like, really, really like, into, what would you say, into religious, but other people, like, they want to be cool.

GIRL 1 They're Muslim, but some people want to be more – don't take Arabic and Islam really seriously. They just take it as a joke, because they're Asian or Muslim or whatever.

GIRL 2 For example, they go to pray, but then they swear and shit.

GIRL 1 They were like this, um, long clothes, and when you pass someone and, imagine they're wearing the clothes, and they swear at you, and you actually think, like, I can't believe they went to the mosque and they come back – and they're like, uh, giving that attitude.

3.

HOUSING ASSOCIATION MANAGER I remember watching it on the news. It was just three girls from the Bethnal Green Academy who seemed to have fallen into the the trap, and have gone over to Syria. They were, what were they, about 15, 16 years of age? They looked fairly innocent, but I I suppose now, you know. Suppose you could look at them in a way now – now they're going to be associated with terrorism. So, I wouldn't trust 'em coming back.

MAN I don't really take a lot of notice of that. I don't know what they're doing, I, dunno – I mean, I'm just – better go and do what they do. I don't know what they do out there.

HOUSING ASSOCIATION MANAGER Haven't got a clue. Haven't really thought about 'em since they've gone. And in some way, I hope they don't come back. I feel sorry for their families, but if that's the way they wanna go about it. Someone's got into their heads.

STRIPPER 2 Yeah! It's almost as if – it's almost like the Muslim equivalent of like the kind of, you know, the rich gap year or when like, you know, all the West London brats get to take a year off from uni and go travelling around New Zealand and just have loads of fun. Okay, I guess it must be the same compulsion to, you know, get out and see the world, but if you're not a rich West London brat, then wh – what other options do you have, you know. Like it's kind of, yeah!

HIPSTER It seemed like they were going through a mid-life ISIS. Like they want to put the hate in Caliphate. There's so much hate already. Or like, their favourite ice cream is vanilla ISIS. So, yeah. It's a big deal. I'm thinking they're the victims actually – because ISIS are not paying their interns. If you look at it economically, they should pay them, cos ISIS are fucking rich. So, regardless of all the killing, I'm looking at it from an economic standpoint. If you rob a bank, if you have

an army, pay them. The worst think is that they send them back and then they get arrested here without even a paycheck.

FEMALE INTERVIEWER So, if they did choose to return, what do you think should happen to them?

HOUSING ASSOCIATION MANAGER Well, they should be arrested and charged as terrorists, I think.

MAN Well, they've gone to fight a war. So, what do you want me to say? Err, they either fight the war or they don't fight the war. I mean, why do you go in the first place for? You know?

HIPSTER I think, depending on what they did. Cos if they actually did nothing, and they had no participation in any criminal act – I'm not sure if filming or doing paperwork for criminals is criminal – but they are clearly under the influence.

PUB OWNER I reckon they should be sent to jail, um, quite frankly. Because if, I as a – my family is from Cameroon, um, West Africa, came over in the Seventies, worked, never claimed benefits, like that. I reckon, if Cameroon and England were at war, and I flew over to Cameroon to fight for Cameroon, and then said, "Oh, shit. I've got a British passport, I wanna come back" – I would be, I would surely be a risk to people in the country, surely. If – if we assume that we're in a state of war with the Islamic State, I think they should be, inter – I don't know if interred is the correct phrase, but yeah, they should be put under some type of quarantine or check because I wouldn't necessarily feel safe, um, and I wouldn't really, I don't, and I think it's a sort of misuse, I think, yeah, um, I think it's traitorous to, to the uh, to having a British passport, I think.

HIPSTER Maybe let them build a fake ISIS camp in Dalston – and let them do it without the dangerous bits. Yeah, because to get unradicalised, first you have to get radicalised all the way. So, you need to let them have it, in a way. Cos life in

London is really boring – like what do you have? So, you look at Facebook, and then you go to Syria.

PUB OWNER So, you watch people's conversations. You watch where, if you get into a conversation with someone, you watch where they are politically and things like that, because you hear stories of people who, like your next door neighbour, could be a really cool guy and then suddenly he's unbeknownst to you – all the while he was, um, buying bleach to, um, create a bomb. I've noticed my parents, um, Islamophobia, if they, you know, I dunno, if there was any latent Islamophobia before, but I notice it's exacerbated now because like my dad – the irony is my dad actually wears like, like a sort of, it looks like a topi, but it isn't. It's a sort of West African ceremonial hat. He just wears it just like walking down the street. So, a lot of the time people come up to him and greet him in Arabic and say, you know, "salaam-alaikum", and then he just says "wrong number", which is his normal response, which is quite comical, and they find it quite funny. He's like, "No, I'm not Muslim". But, um, but I notice that he has a very, um, he has a very sort of English standpoint. He's like well, you know, uh, he doesn't say it in a cockney accent, but he's sorta like, you know, "Can't be living over here and be against the country, and this and that, and wanting to blow things up" – it's a very sort of English response to it.

HIPSTER Maybe they can use it as an advantage? Cos like, like if I'm desperately trying to fall in love with a Muslim lady, a hot Muslim lady who would take me to Cairo – and my life would be much more interesting than walking around Shoreditch. Imagine if they forbid dating Muslims – everyone would date Muslims. You want to do it because it's dangerous – and ISIS have just made it more dangerous and more risqué in a way for people who are bored with their lives. Many of my friends, I'm sure it's like if you ban drugs, everyone wants to do it. If you ban dating Muslims, it's gonna be a thing. I'm not suggesting it, but I'm saying that's the attraction.

4.

As this section finishes, or when an actor simply has no more lines, those on stage begin the process of 'brownface' – transforming themselves into Muslims. This process is both obvious and unsure – obvious because it is cartoonish, unsure because no one is really sure of what they are supposed to look like.

HUSBAND 2 In the community here, they do a lot of stuff for the Asians – like, the mayor was Asian, the councillors are Asian, and this was Asian, and that was Asian – the Asian elders. We ain't got no elders. And we was like put on the back foot. And anything we said was like – it would have come out like you're racist. I'm not – I ain't got a racist bone in me body, but the way you say it, you gotta be careful with the way you say it. I worked for the council for 23 years.

WIFE 2 How many years? 25!

HUSBAND 2 25 years. I was the area manager. So, I see a lot, a lot of changes – massive. Spitalfields, they got one area, that's only for Muslims. No white people in there. Instead of integrating people, they integrated them to themselves, and not put in, like, five white, five Chinese, five black, five whatever. They never done that. They stuck all these Asians in one place. So, that's why got control of that.

WIFE 2 They've got no, um. They don't wanna, it seems –

HUSBAND 2 They don't integrate with us.

WIFE 2 No.

HUSBAND 2 What it is, they used to build plenty of mosques, all over the place. Like, we used to have a housing office over there – they turned it into a prayer room. Where's the churches? Not one church has been built. They've actually turned churches into flats – because of the Muslims. The pubs! There used to be loads of pubs around here – you could go down and enjoy yourself, and have a drink or whatever. They're gone. They're

gone. Bethnal Green Road, you could walk down Bethnal Green Road, Old Bethnal Green Road, do half a pint in each pub, and you're pissed by the end of it. Serious! Serious, it is! Now? Nothing.

WIFE 2 Now there's no such thing as that.

HUSBAND 2 Nothing like that.

WIFE 2 We've been married 33 years, together 36 years, and we've noticed so much down here.

STRIPPER 4 In Bethnal Green Road and Whitechapel and, erm, like, it's funny because Whitechapel particularly, I, you know, obviously see like, you know, a – a much higher percentage of, err, you know, brown skin and Muslim face, and like I work – I worked in a club in, erm, London, in, err, Whitechapel for a few months. It's on Whitechapel Road. And there were a lot of Muslim guys who used to come in there, I mean, it's run by Muslims. The guys that own that place are Muslim men, eh, well, not extreme Muslims, I guess. They might just be Asians, you know, like, erm, yeah, I don't know, there kind of cultural heritage, but, but yeah, I mean, that to me, I find that, I found that dynamic quite interesting because on the one hand it's quite well known that the Muslim community in Hackney was very vocal and pestiferous about like, you know, there kind of making, you know, getting strip clubs shut down. And on the other hand, like the men in the community do, like, ya know, kind of, they want to come and look at women, but they're more likely to actually, erm, they're more likely to see us as sex workers and prostitutes. They're more likely to ask us if we'll like, ya know, go to bed and how much it is for sex. And it, I dunno, I just, I kind of, I personally, I feel like I have kind of have little moments of very private insights into the Muslim community.

CAMPAIGNER I am disgusted by the fact that in Britain today we are having a debate about whether or not we ought to be able

to speak freely about Islam. To me, the biggest danger is our freedom of speech – censorship, self-censorship is becoming more and more of an issue, and we seem to be ignoring it and seem to be pretending as though it's not a big deal. An offence is a subjective thing – we can't restrict free speech on who might be offended. Everyone is offended by something. This is a huge issue to me. And also women's rights. Decades ago, a century ago, the suffragettes won a lot of the battles – women being property and women not being allowed to vote – and essentially we have the same argument going on again.

STRIPPER 4 I don't think that women have, err, a lot of respect in, like, the Muslim world. I've, you know, I do think that I'm – I do think that there is a kind of problematic, err, God, it's a good job this is anonymous.

MALE INTERVIEWER No, no – I mean this is amazing.

STRIPPER 4 I dunno, man. I – Sharia law, I think is preposterous, right? So, you know the fact that, you know, their women should be kind of brought up to choose to cover themselves up, to, you know, their conditions to want to, err, yeah, like, erm, keep themselves hidden, erm, in public, because like I said, I'm seen as a whore. Like, it's pretty fucked up but at the same time, like, it's not, ah – I don't think that's the worst thing women can be subjected to, or, I just, I just, dunno. I – like really, I'm a feminist, but I don't often apply feminist thinking to, erm, Muslims.

CAMPAIGNER In my personal view, the children were getting younger and younger that are wearing these, over the years. I mean, not long before I left, which really shocked me, I saw a girl in a pram, perhaps two years of age; wearing a hijab – and that was something I'd never seen before. We are told, and we read a lot about how women are treated under IS ideology. So, one must marvel at the fact that a woman would voluntarily go and put herself into this position of subjugation. I do think the media pays more attention to when girls do it – but also

they seem to paint these girls as victims. And I'm not sure I agree with that, actually – any more than the men. I don't see why the women are victims when the men are not. I think one of the things we leave out of this is the actual, there is, certainly, religious devotion. Why do we always look for a reason other than religion for why people do these things?

HUSBAND 2 Well, they're, they're, they're terrorists, ain't they?

WIFE 2 […]

HUSBAND 2 They're terrorists. No one dragged them over there – they went themselves. So, they wanna be terrorists. They're born in this country; they go over to Syria and all this business, you get all these Asians, they're born here and they go and fight against us in Syria and all that sort of stuff. That's bad! We oughta go and kick the whole lot out! That's what I would do.

WIFE 2 Send 'em out. That's what I would do. Send 'em away.

HUSBAND 2 Definitely.

WIFE 2 Go back. Go away. And another thing, to me, right. I might be outta turn when I say this, but this country is finished.

HUSBAND 2 Yeah.

WIFE 2 They should not, they should – they should go by what we say. It's our government's fault. It's not their fault. It's the government's fault.

HUSBAND 2 Right. They've put the pressure on.

WIFE 2 It's just not on. Every flat you've got – all full of Asians.

HUSBAND 2 They shouldn't come back. They shouldn't come back. They've chosen their way of life – that's the way they choose it.

WIFE 2 Let 'em stay there. Don't let 'em back.

HUSBAND 2 Yeah.

WIFE 2 Don't let 'em come back.

HUSBAND 2 They wasn't forced to go.

WIFE 2 No! Let 'em stay there!

LISA walks out of the show.

HUSBAND 2 They weren't kidnapped and told, you come here. They went of their own free will.

CAMPAIGNER I think they should be prosecuted. I think they should be prosecuted, yeah. You can talk about the social reasons behind why people commit crimes, but you've got to run a society along the lines of personal responsibility – or it just won't work. We can't hold people accountable for someone else's crimes. If the person commits a crime – the whole legal system is based upon accountability for one's actions – and I don't think we can make exceptions for this. Why should we? It's a crime. It should be prosecuted as a crime.

WIFE 2 I work in a hospice. All his life he works so we can save a little bit of money. We asked for a little bit of money towards our rent, and they said no, cos we've got savings. Is that fate?

HUSBAND 2 Yeah.

WIFE 2 Is that fair? Been working since we were 14. It's ridiculous.

CAMPAIGNER It gives no credibility whatsoever to fighting the ideology abroad if you're not going to fight it at home. In terms of, I mean, I don't know – sometimes I'm in favour of military action, I think I probably am still. It's just a really difficult question. The British government has a responsibility to protect British citizens including obviously Muslim citizens. And we've got to get a grip on this, this is really dangerous, and we're going to have to start taking some tough measures. First thing we have to do is stop treating these people like victims – they're not. They're aggressors.

5.

The entire cast are now speaking as a chorus of 'Muslims'.

MUSLIM 1 I remember thinking one of them reminded me a lot of my sister – and that unnerved me. It kind of made it all the more real for me, you know. You usually see these people and forget their humanity – like, the families they leave behind. They're just traitors. We forget they're someone's child – or sibling. So, when they resemble someone you love, it brings it all back home.

MUSLIM 2 I didn't know them, actually – just heard and seen stuff, well loads – on TV. It's like, yeah, I do feel for them because they clearly thought it was their only option – felt trapped, maybe. I'm not sure. But in all honesty, I can't help but be angry at what they did. Because, all it takes – it's just three girls, going off, and suddenly everyone thinks, like, I'm going to run off, too. I grew up here. I like it here. For real, it's nice – the people, erm, school, shops – it's nice. I'd find it hard to think that someone who actively participated in stuff would then run off like that. You give and take, right? *(Beat.)* I didn't know them, but still, you know what I mean.

MUSLIM 3 Oh, definitely – definitely. It's, um, it's – if you're living in England, are a British citizen, then, err, you're provided for by the state. It's wrong. It's not on. And I apologise. We're not all bad, like I already said, that's not what Islam is – and yeah, we don't condone it.

MUSLIM 4 It was awful. There was lots of finger-pointing – and a lot of since, too. It really made me question – made me question my faith – the religion that they name as their inspiration. It was a really uncomfortable time. I even felt guilty. I'm not sure what about, but I did.

MUSLIM 5 It's just so – so unnerving, really. Because – and in a way I feel a bit – responsible, really, I mean – I saw them

every day. How did I not – The whole thing scares me. I mean, how many other young girls in our community have been targeted? How many? Because, like, it's not they – I don't know, suddenly get all secretive and suspicious. So, how am I supposed to tell?

Suddenly, the adhan [call to prayer] can be heard in the distance – as though it is coming from a mosque down the road. A couple of actors might stop – unsure of the sound.

MUSLIM 3 The reality's that these three impressionable young girls believe that British culture isn't for them. And l feel like we've let ourselves, our religion, down. This glamourisation of jihadi brides is something we need to erase. Once again, it's a minority within our faith who've created such a detrimental image. But still, we stand resilient – and united.

A young Muslim man in the audience stands up and shuffles past everyone on his row. He calmly walks to the front of the room / stage / corner. He and the other interviewer might share a silent moment together.

MUSLIM 2 I share the view – with most of the British public, I'm sure – that they should be arrested and imprisoned. But I, uh, do believe they should be allowed back into Britain. I don't think they should be, erm, deported. I totally condemn those girls' actions, I do. They offend me not only as a Muslim – but as a human being, too.

MUSLIM 6 It's really tough. I think they should be sent to prison. They should be made to go through some sort of deradicalisation programme – to break the cycle, you know.

MUSLIM 4 I don't think they should simply be thrown in jail. But I don't think they should just be released back into society either. I definitely think they should receive some sort of counselling – help of some sort, you know – in a secure unit, or something. Somewhere where their families can come visit and see them progress until they're ready.

The young man begins to pray. This is not a violent interruption – it is simply time to pray.

MUSLIM 1 We seem to have forgotten something. These are just three young girls. What we need to ask ourselves is what has gone so wrong in these girls lives that they felt they had nothing else left other than to go to Syria. For girls so young, I find it incredibly troubling, I do. The one thing the media has made such a fuss of is the fact that they're Muslim. Yes, they are – we can't ignore this. But they're schoolchildren first and foremost.

MUSLIM 4 It's an extremely culturally diverse place. There's a large Muslim community, of course – but I think the best part is the relationship between communities. I think that's the best part of being British, of living in Bethnal Green – the multiculturalism.

MUSLIM 2 From what people told me about Bethnal Green before I moved here, I, um, I expected it to be, you know, it's population being, like, 90% Muslim. But it's actually a lot more diverse than that. I love its diversity. The Muslim community's prominent here, and has, err, a strength of voice – don't get me wrong – especially since we feel the need to speak out against the extremists tarring our name. But it's a great representation of modern London.

MUSLIM 5 To be honest, erm, everything feels more – what's the word – disconnected. The Muslim community seems to create a strange atmosphere for others – which it didn't use to. It's difficult, I understand. I really do understand why it happens. It's scary, the whole, erm, situation's scary right now for everyone, including us. But I just hope it gets better. It's more difficult with these girls leaving, but we just need to talk about it, you know.

MUSLIM 1 We focus on terror and suspicion – not on facts.

MUSLIM 3 It's only natural. After such horrific events, hideous crimes – it's justified for people to respond fearfully, and that fear will, even subconsciously, spread. It's like, if a child gets bitten by a dog – one dog – they'll be afraid of all dogs, right? Run away if they see one. Not the dog that bit them – any dog. It's the same.

MUSLIM 6 We used to be accepted. My son's had quite a few issues at school – with bullying and that – calling him names, nasty things. It's like we're all the same to them. It makes me so angry. We're being misrepresented by barbarians like ISIS, Jihadi John. I just want to live in peace like everyone else – work, have a family, pay – that can't be too much to ask for? Why won't they just let us be?

The action onstage starts to grind to a halt as the young man continues to pray – a few actors try valiantly to keep things going, but in the end, they fail.

MUSLIM 4 We've become the boogie men. And it's being perpetuated by sweeping generalisations. But also, these events have highlighted some fundamental problems – particularly with the ways in which people are interpreting the Qur'an now. Awareness is the first step to solving the problem. It breaks my heart – it really does. Seeing my faith being twisted into something it's not by extremists. I'm angry.

MUSLIM 5 One's faith is a private matter. I think it's wrong that some people shove it down other people's throats.

MUSLIM 2 I think the Muslim community should be taking responsibility – acting to eradicate the ignorance shown by people towards Islam. I mean, how can we just sit back and let all these disgusting terrorist acts define our religion to the rest of the world. We have a duty to change something here.

Cut to black.

Tyler the Creator's 'Radicals' starts playing at earsplitting volume.

fly πrates

Lightning Source UK Ltd.
Milton Keynes UK
UKOW01f0305251017
311592UK00015B/386/P